Pascal Baetens
The Art of Nude Photography

Pascal Baetens

The Art of Nude Photography

Amphoto Books
an imprint of Watson-Guptill Publications
New York

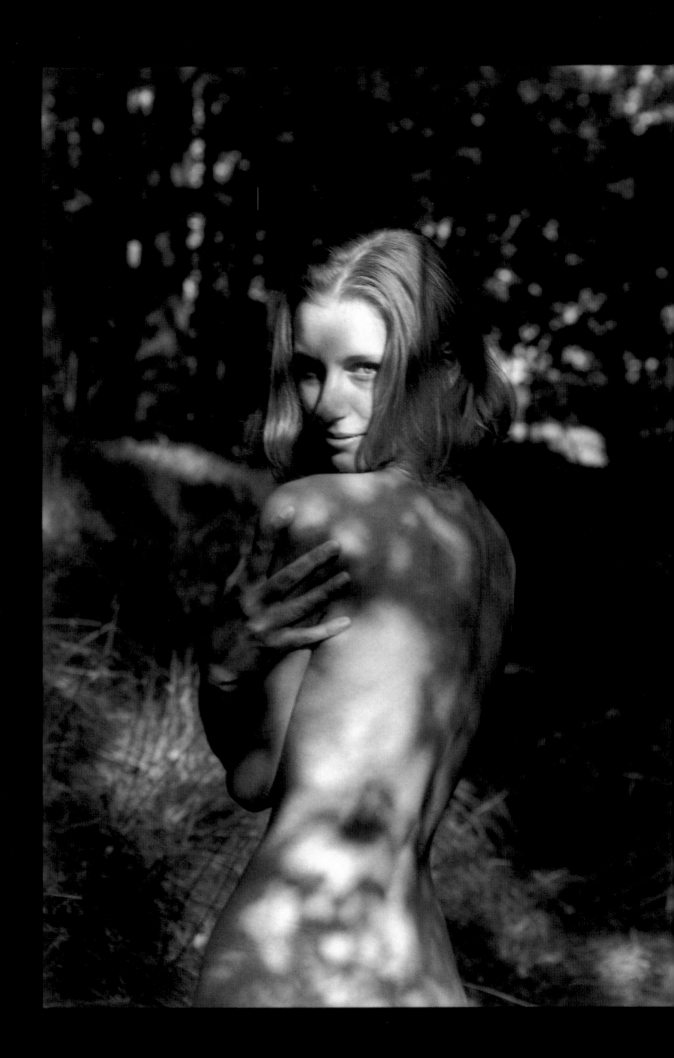

The Nude and the Photography of Pascal Baetens

When one is asked to contribute a preface or an introduction to a book, it is expected that one will discuss in great detail the work of the author. In this situation I would not know what to write, as I myself have photographed the nude for over twenty-five years and I have never been succinct at talking about the work – thank goodness I am capable of expressing myself with the camera instead of the pen!

Pascal Baetens is a good guy – affable, engaging and sincere. He's very interested in photography and has a good grasp on the history of the art/craft as well. I find in most young photographers a lack of interest in learning about what came before them but in Baetens' case he has done his homework. He writes on the subject, he reports for various magazines and is both knowledgeable and personable, two essential qualities for a good photographer. He organizes photo festivals and exhibits for other photographers as well as for himself. He participates in photography.

As I do, I believe Pascal Baetens lives and breathes photography. It is essential for his life – his oxygen. This is the first qualification for greatness if greatness is to be achieved. One must be possessed – obsessed – driven – willing to spend all of one's waking hours in its pursuit - and be perhaps slightly mad. While I'm not sure of the latter in his case, I am sure of it in myself! This may be a prescription for artists in all disciplines.

I've met and become acquainted with many photographers – hundreds in fact, and I know it when I see it. Baetens is on the way. His work reveals energy, a discipline and a love of his subject. Of course his images are well composed and the lighting is beautiful but there is also that something else – that essential something that you either have or you don't – something you can't learn. That something is the ability to reach your subject – create one's vision and have the complete complicity with the subject. I see this in Pascal Baetens' work. He communicates with his subjects – controls the situation and has the ability to bring his communication with the subject into the image. This is an intangible!

I'll be watching his work in the coming years. He stands a good chance of making his mark on photography.

Jeff Dunas, Los Angeles, December 2001

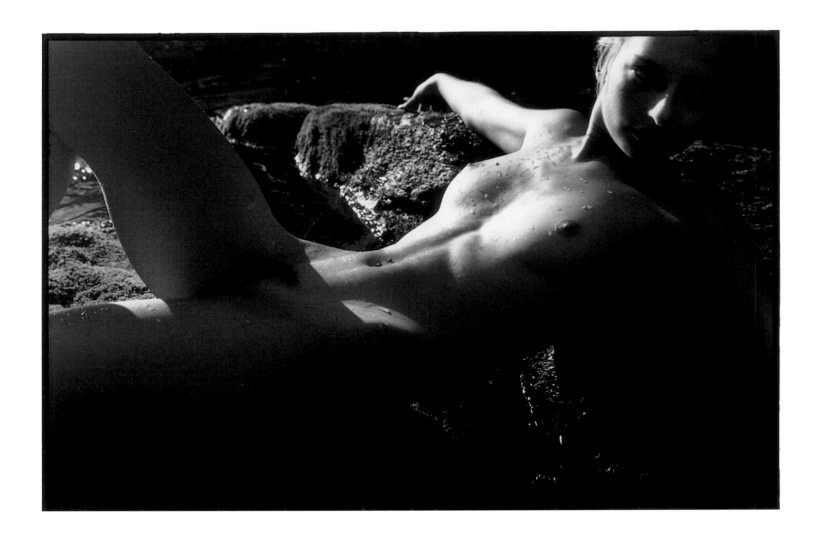

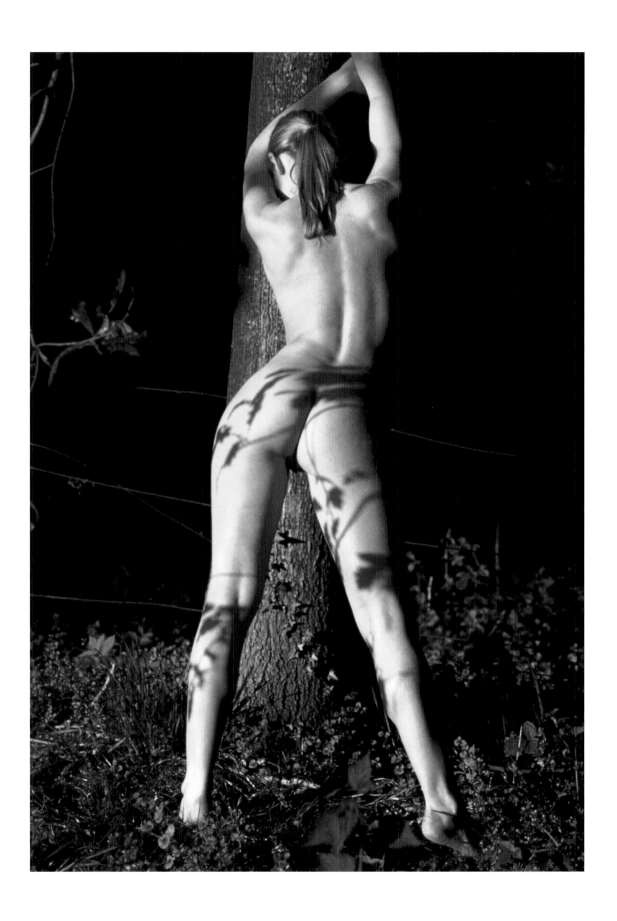

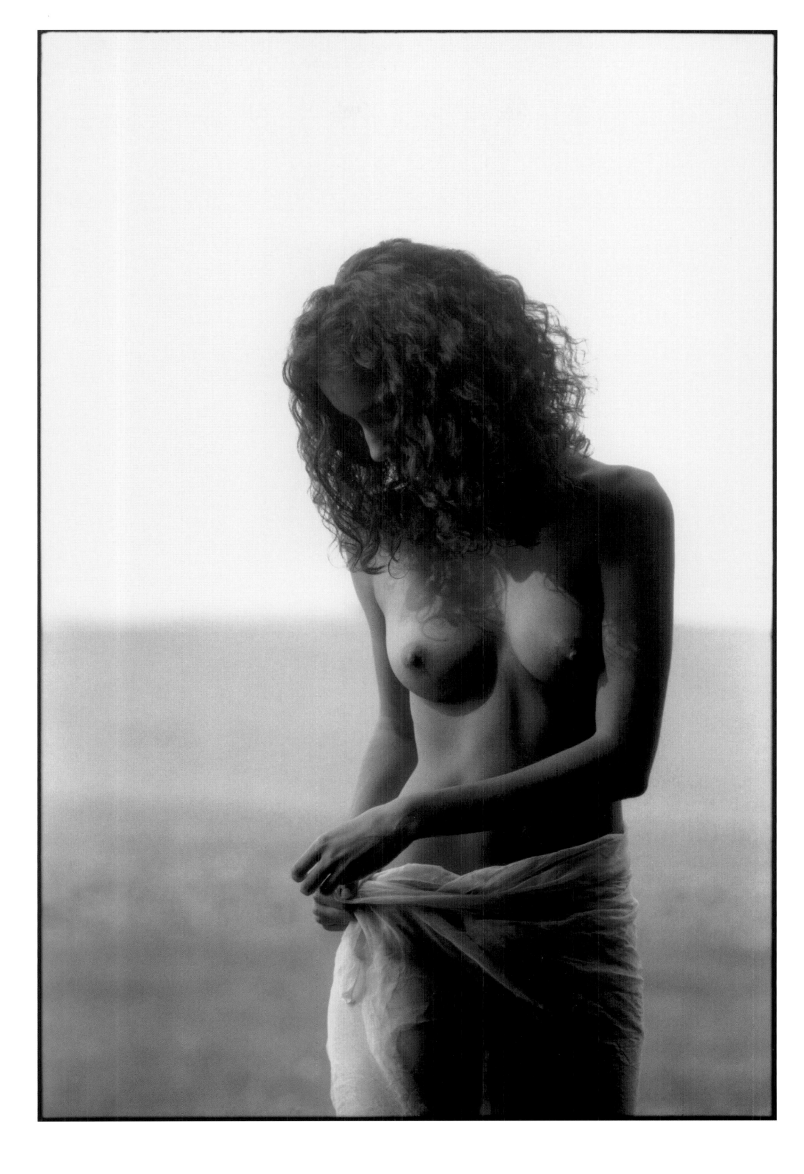

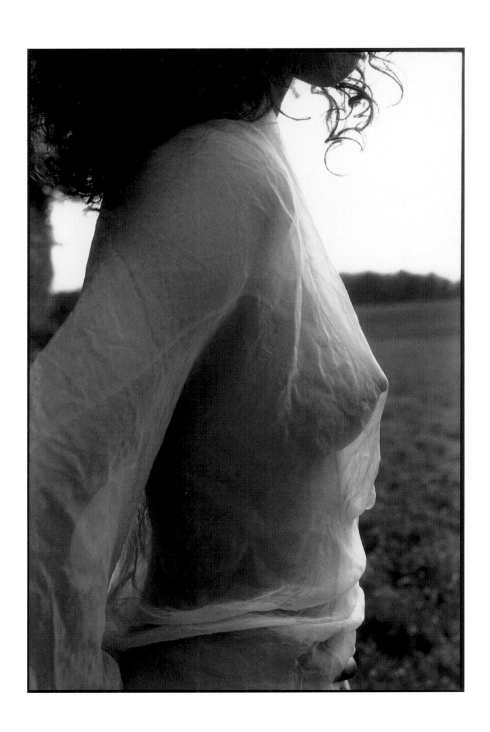

10

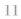

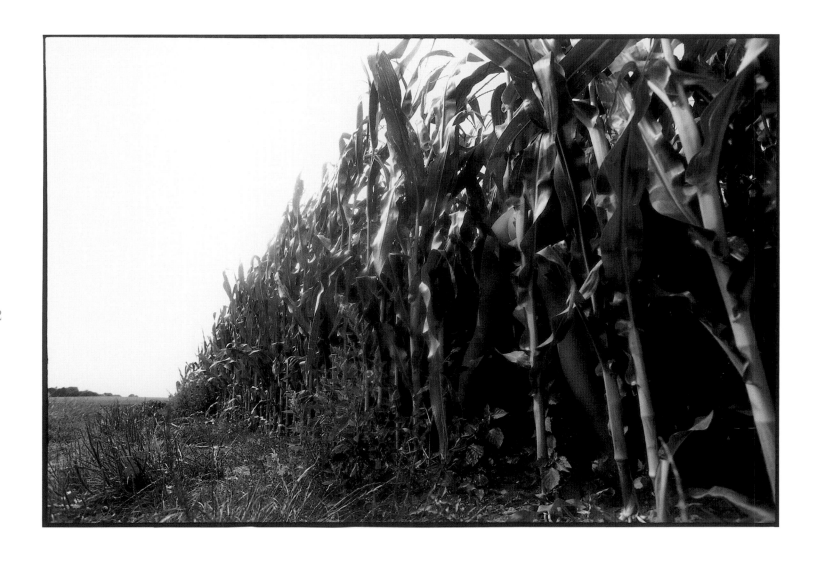

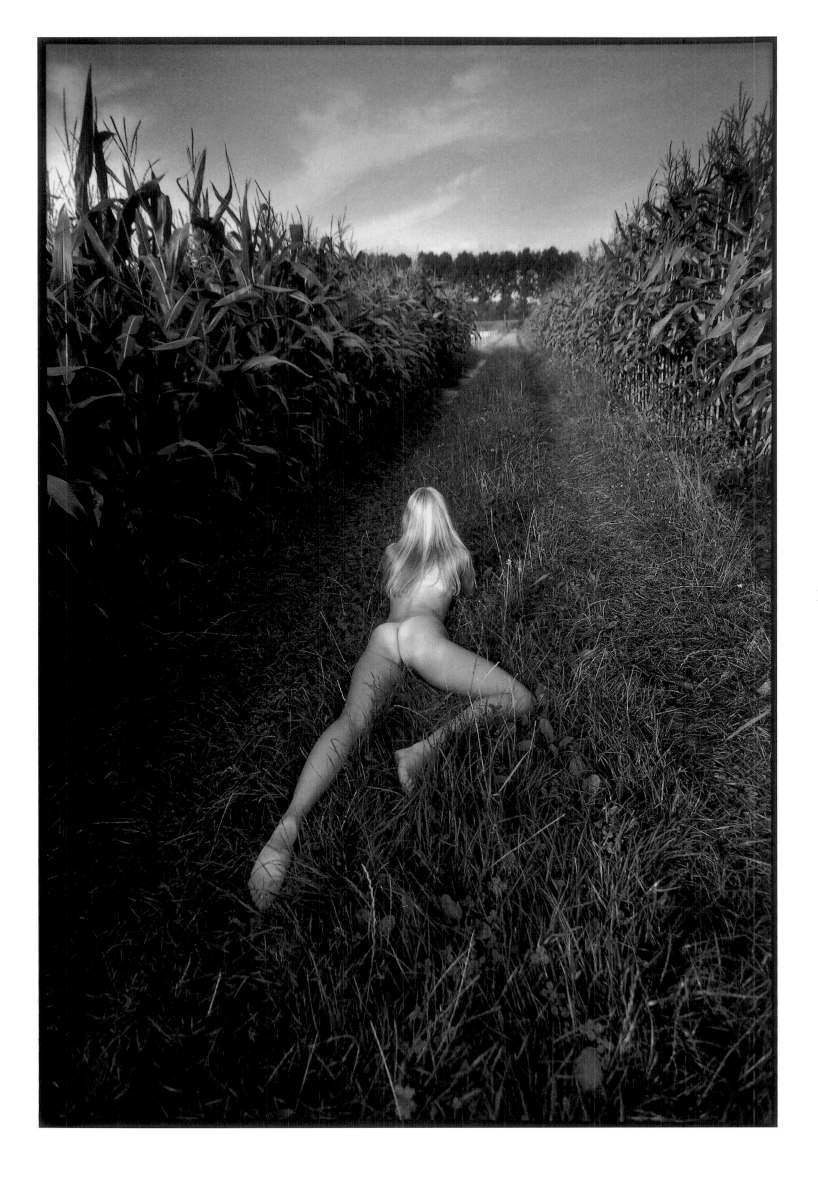

13

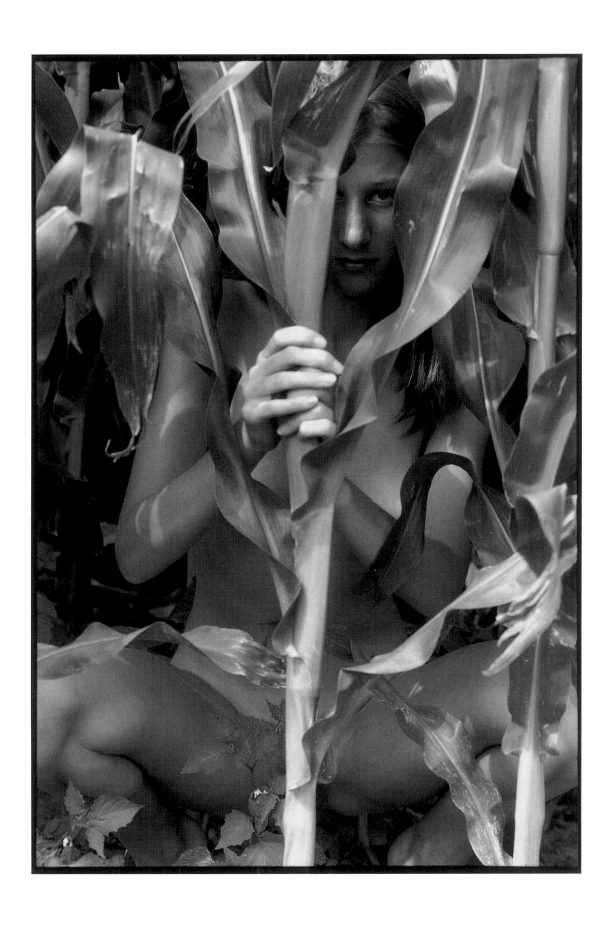

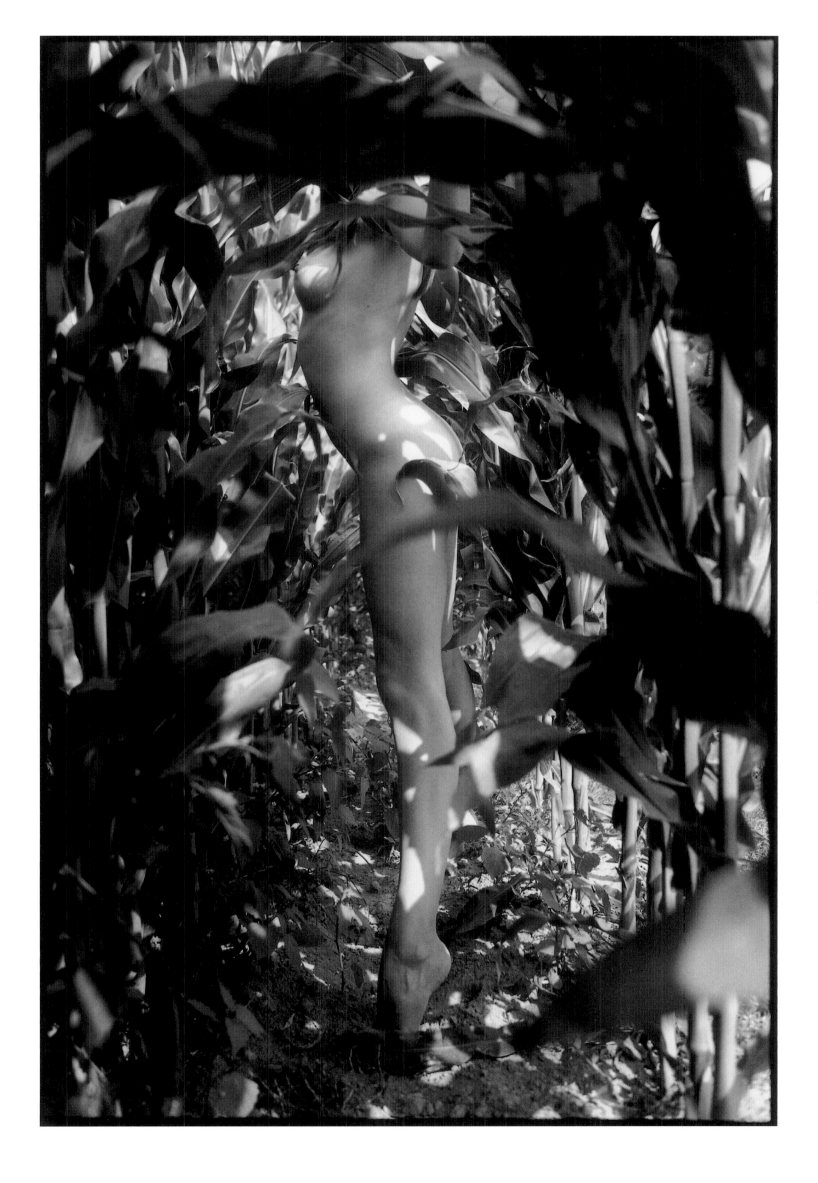

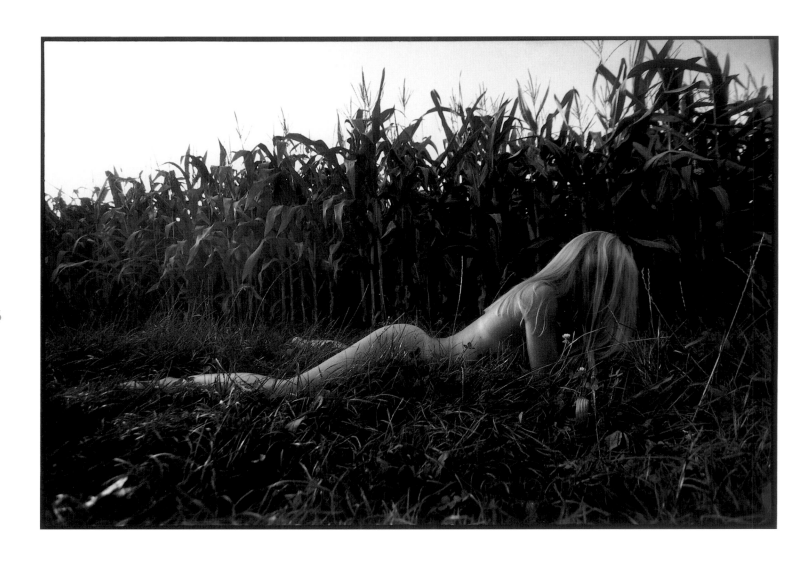

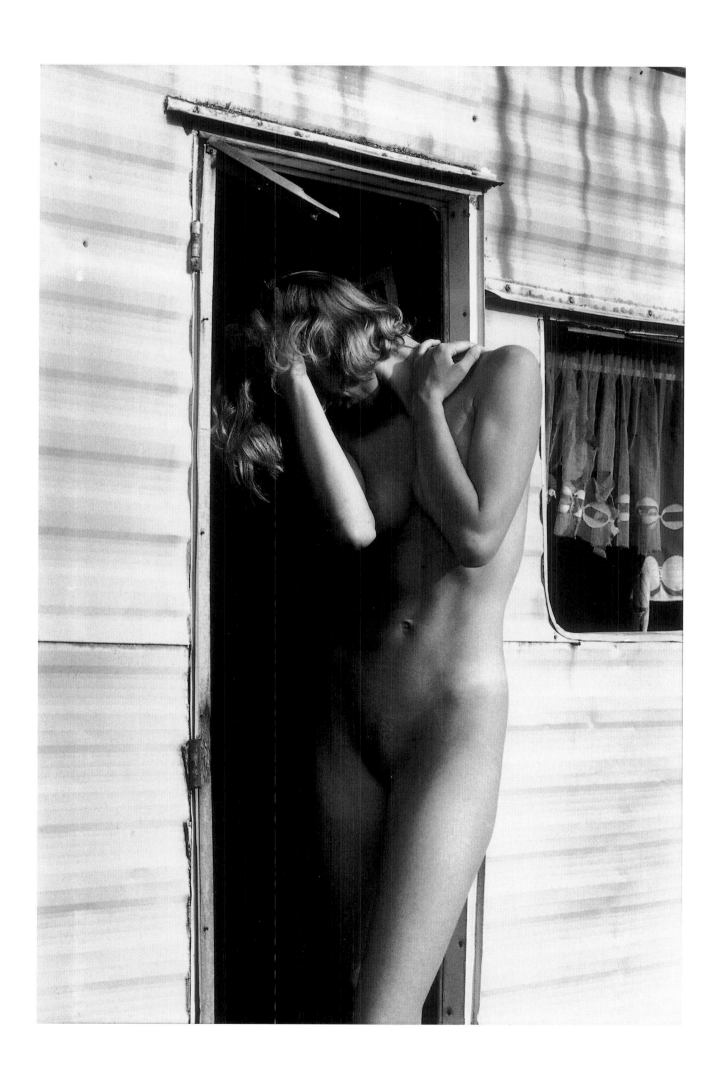

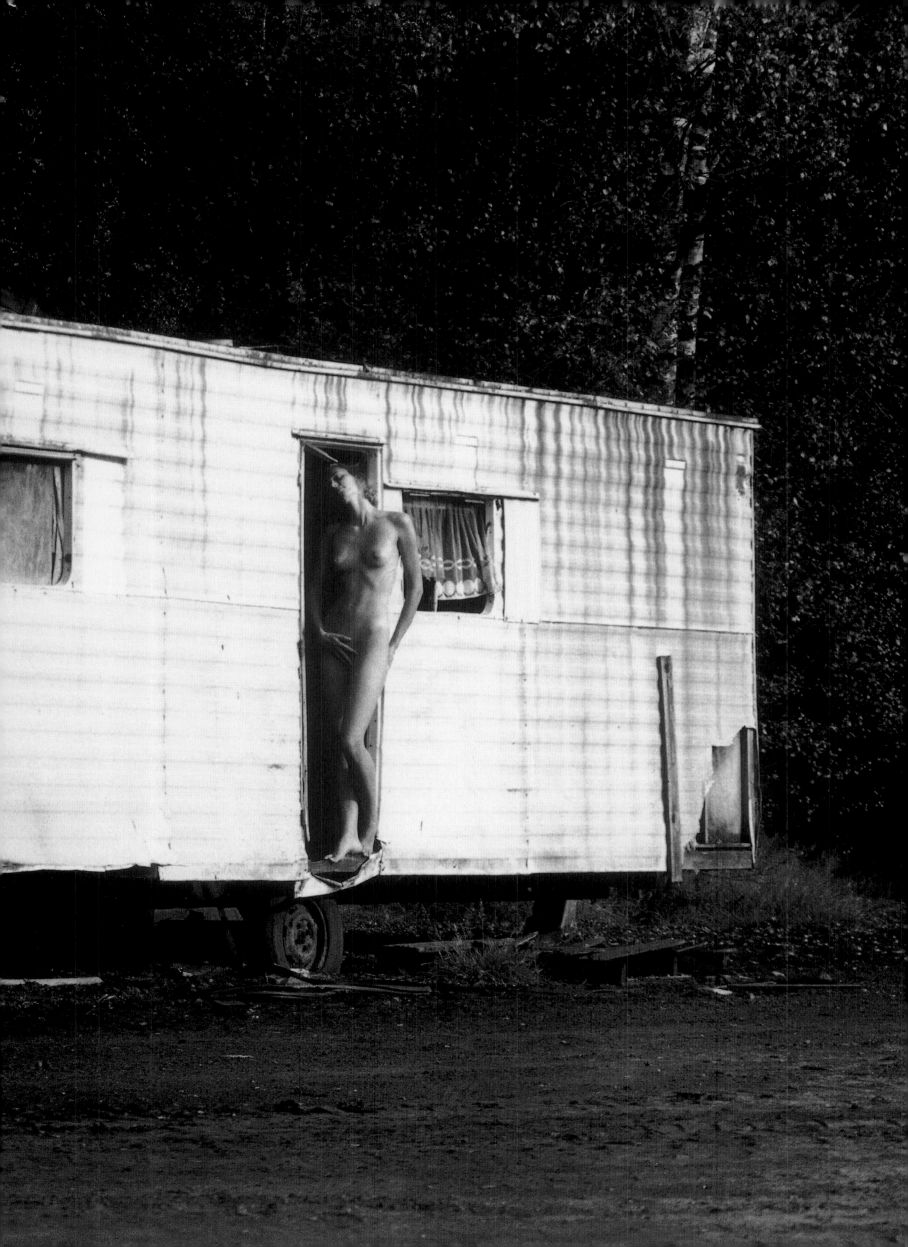

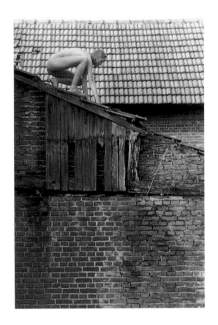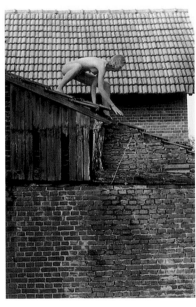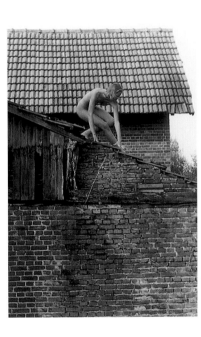

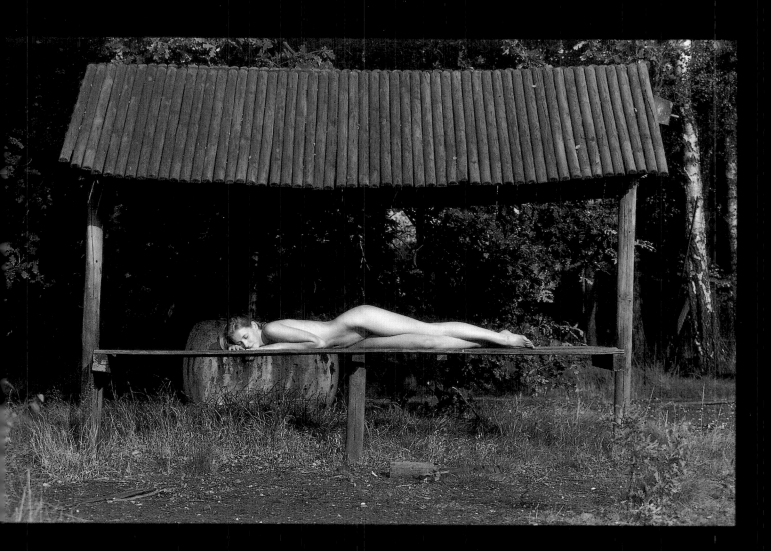

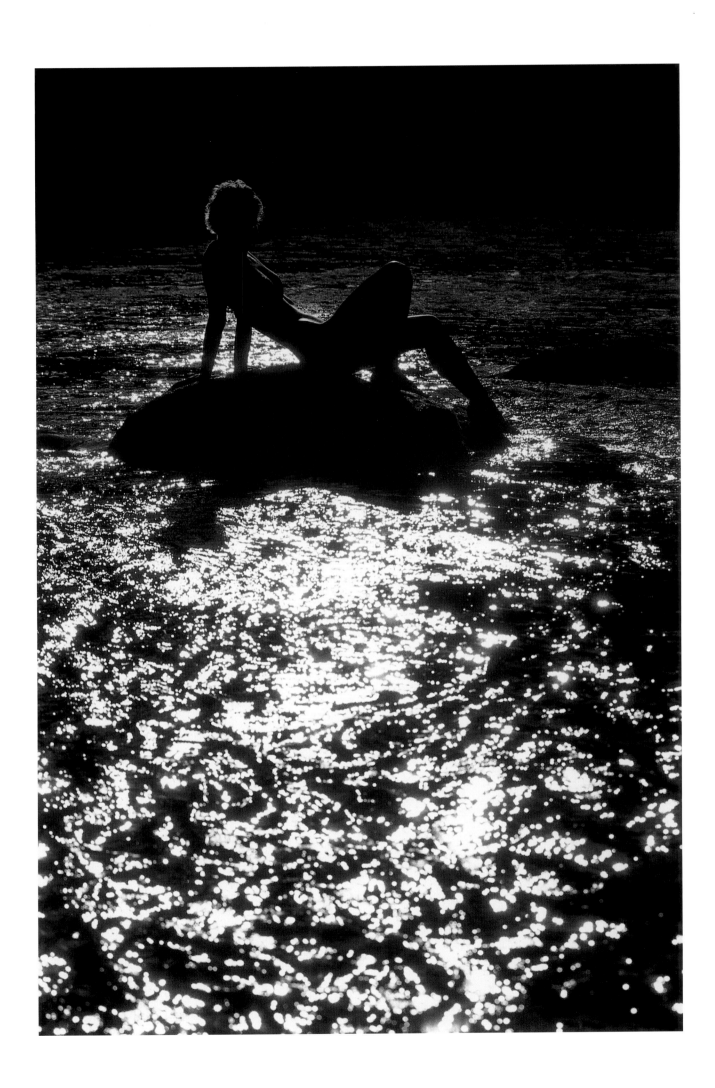

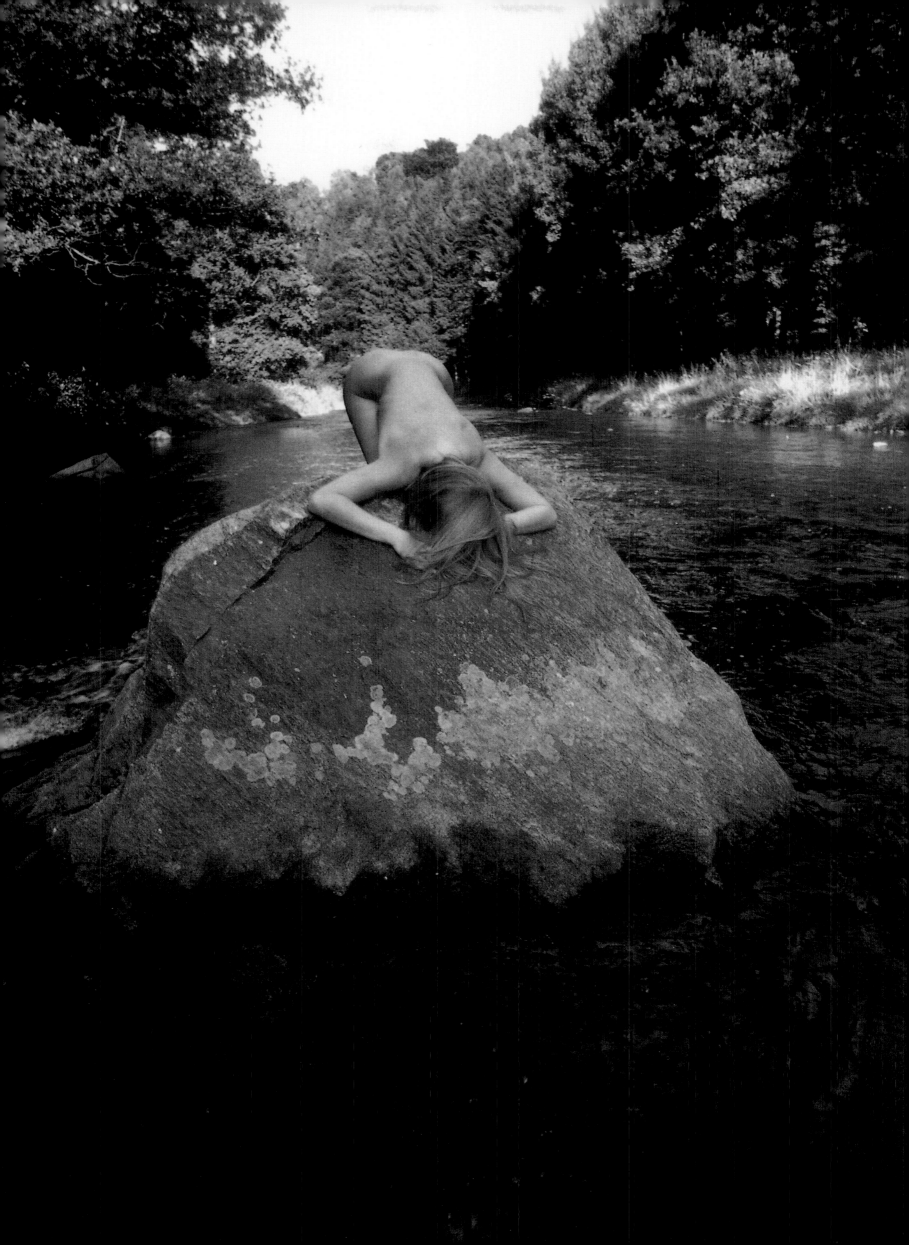

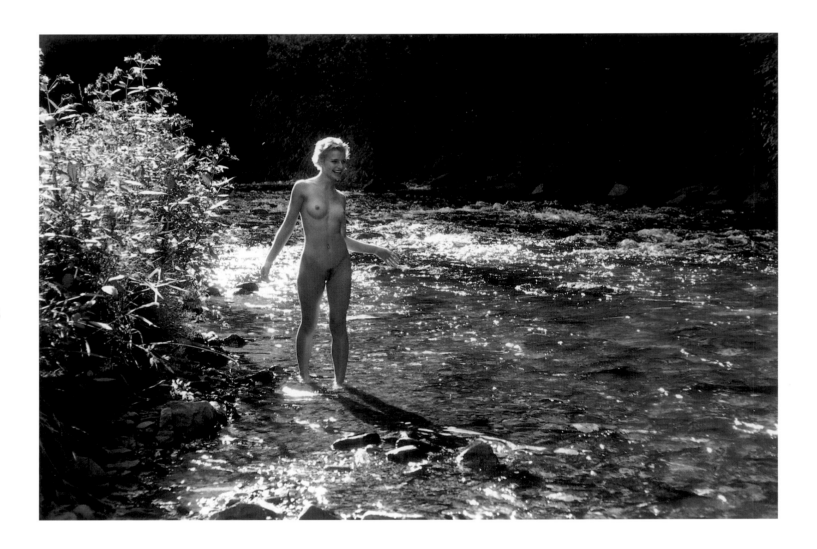

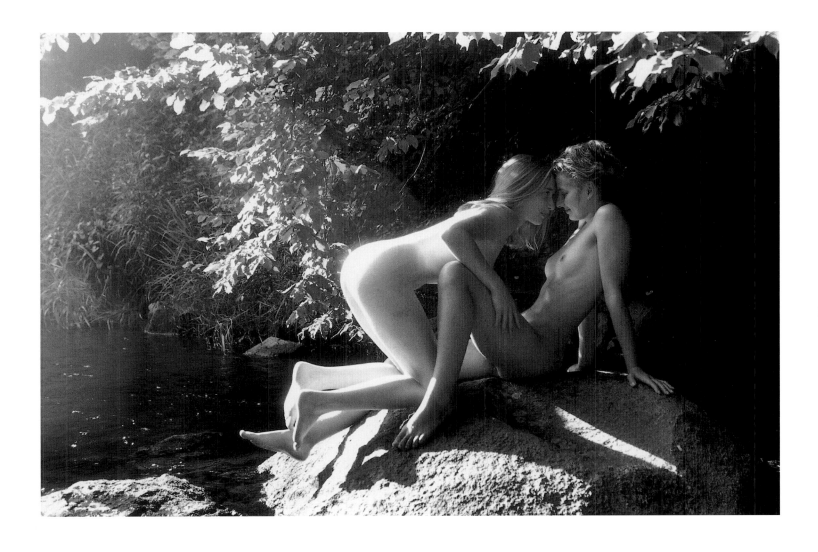

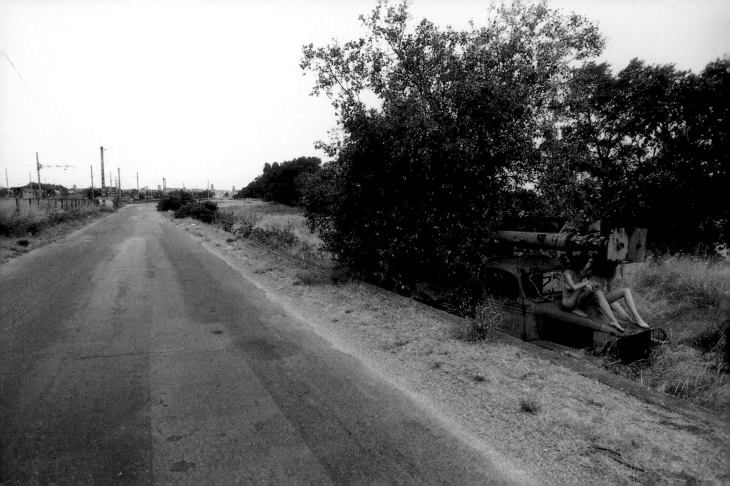

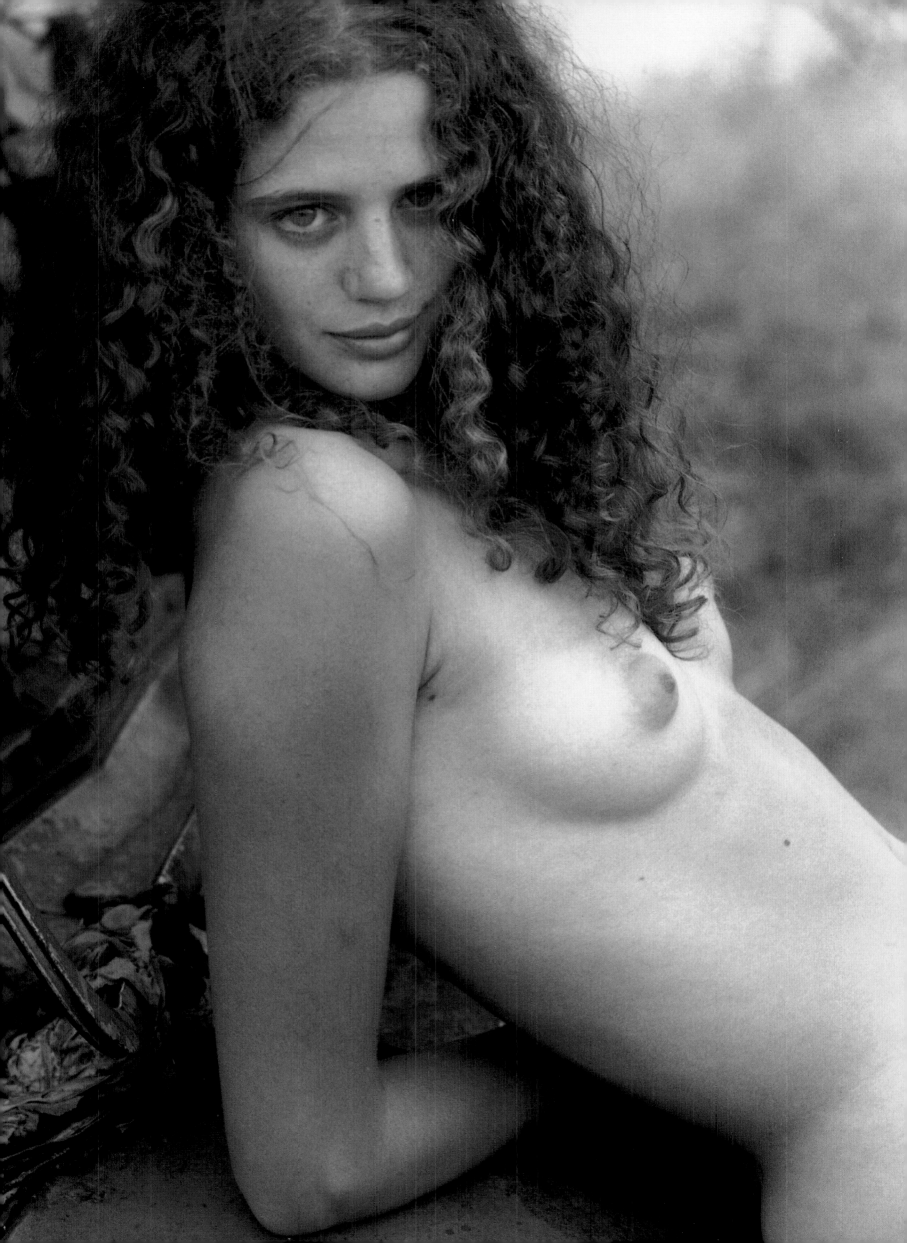

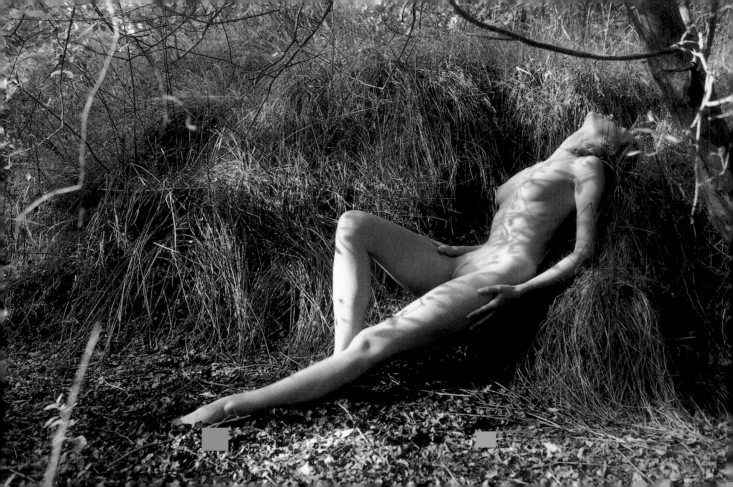

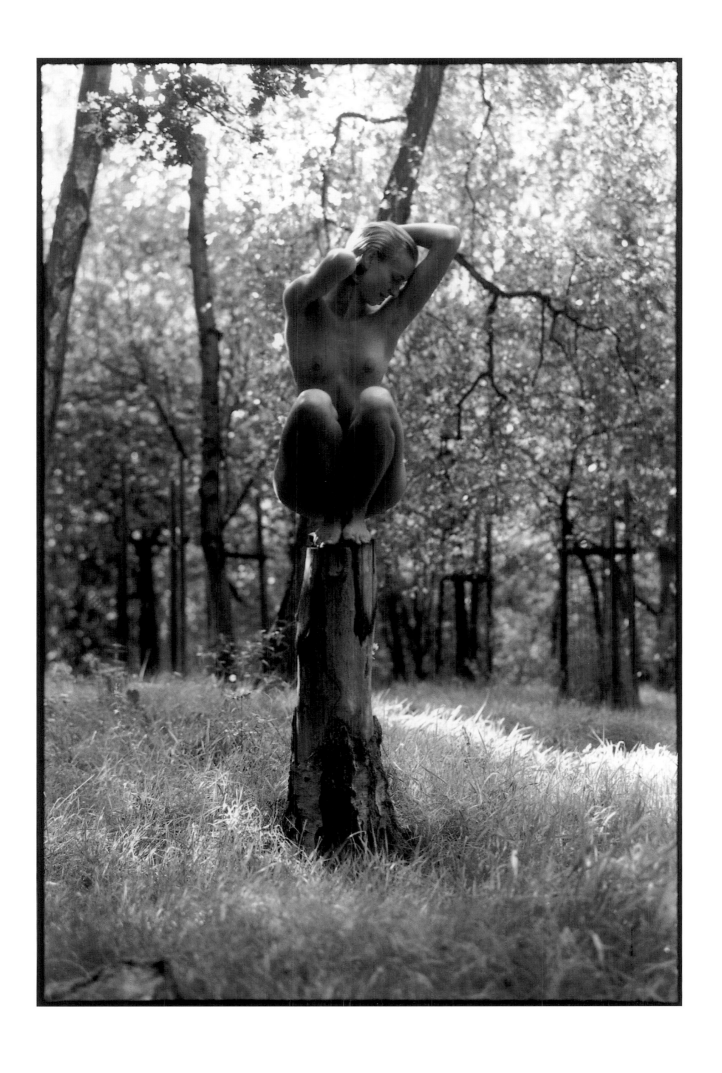

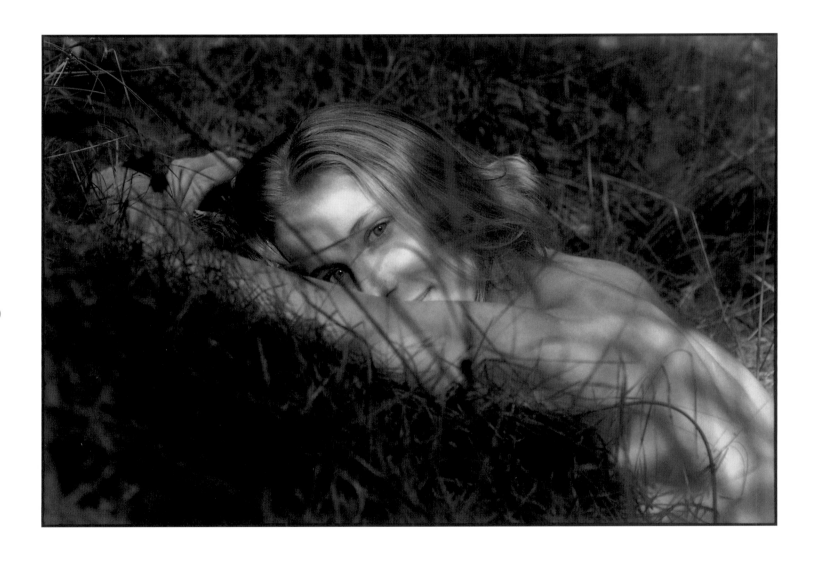

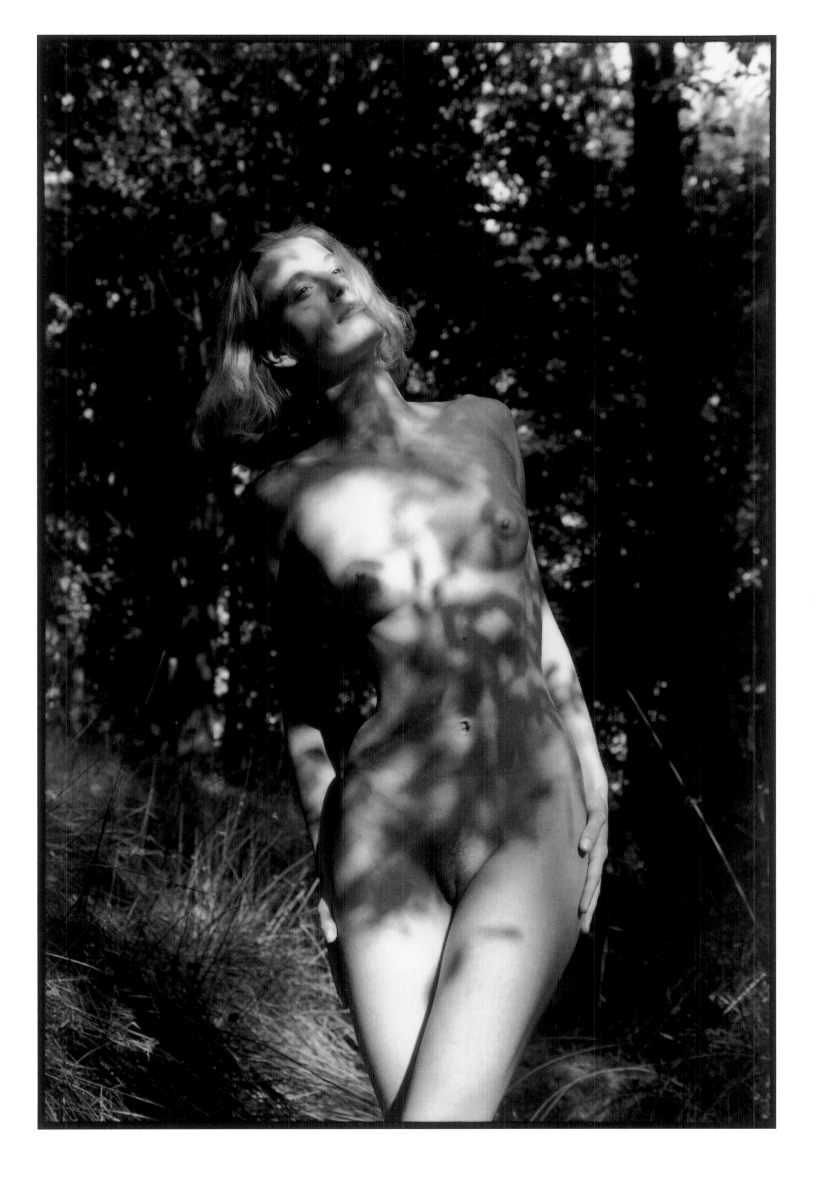

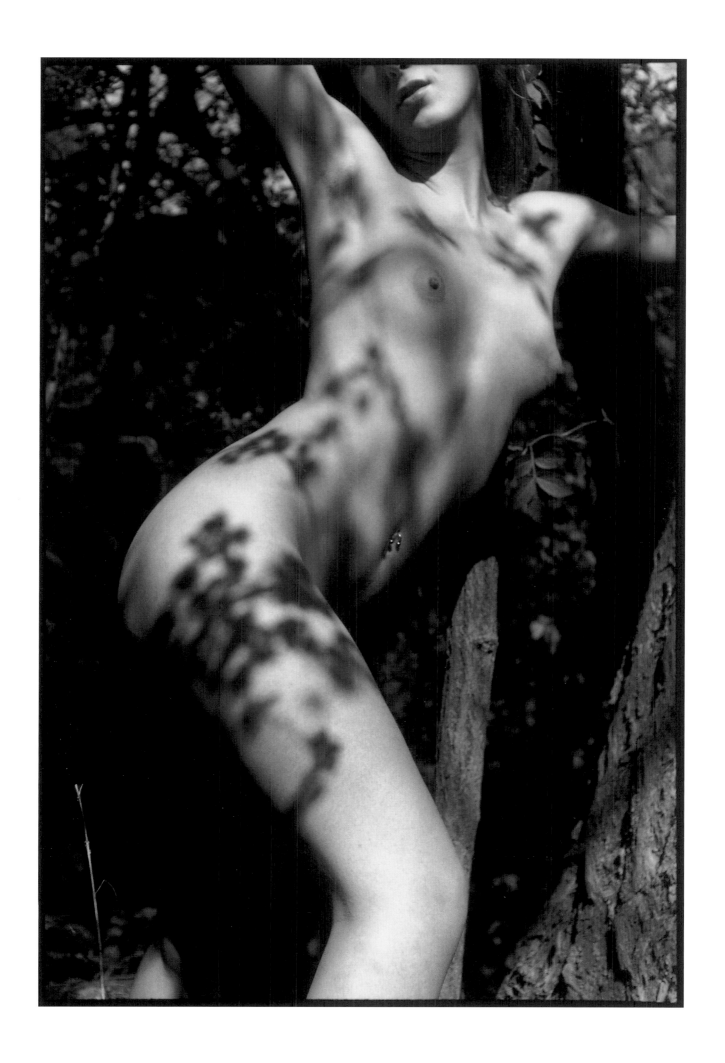

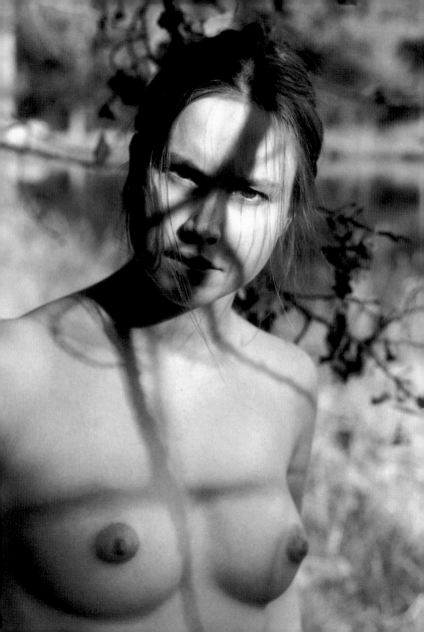

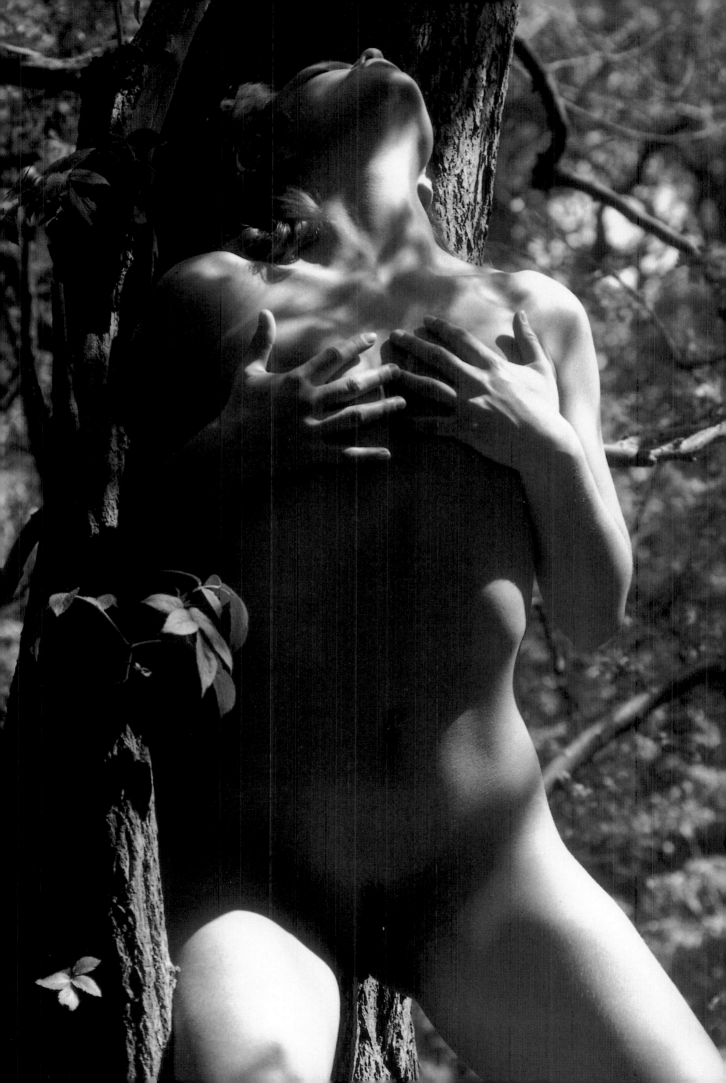

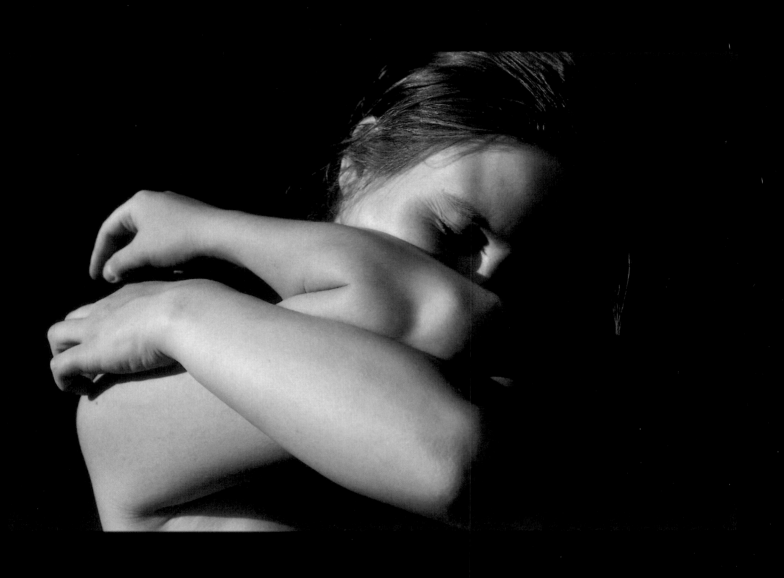

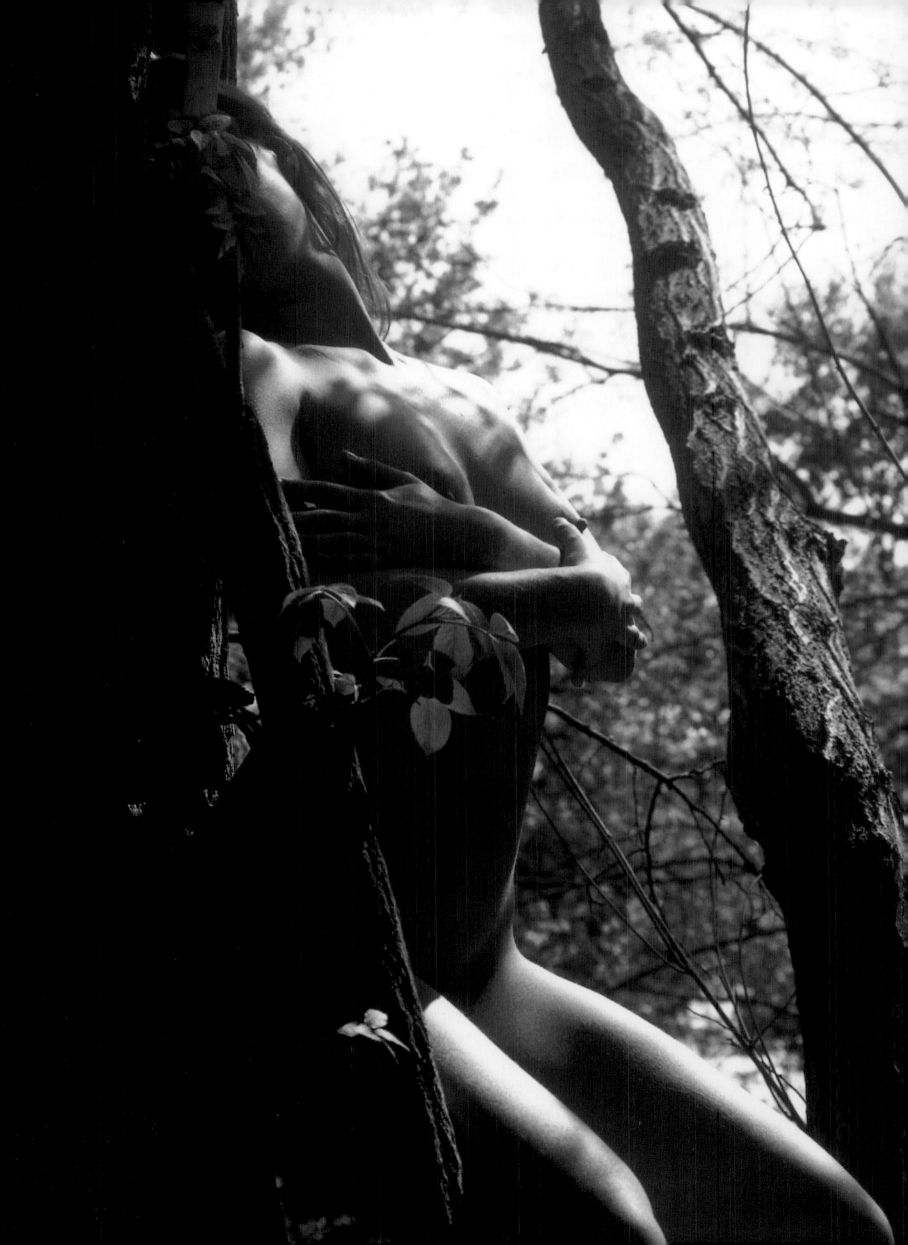

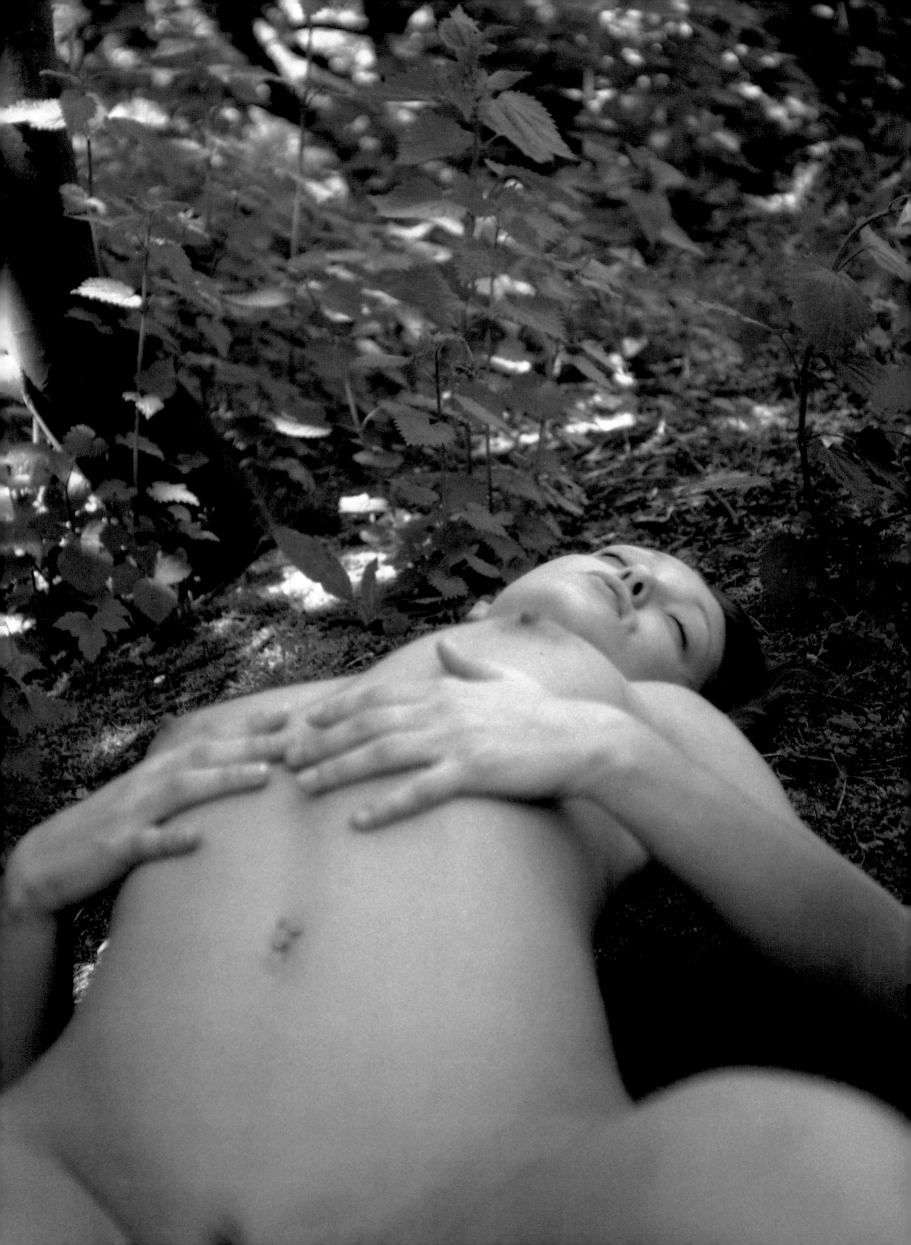

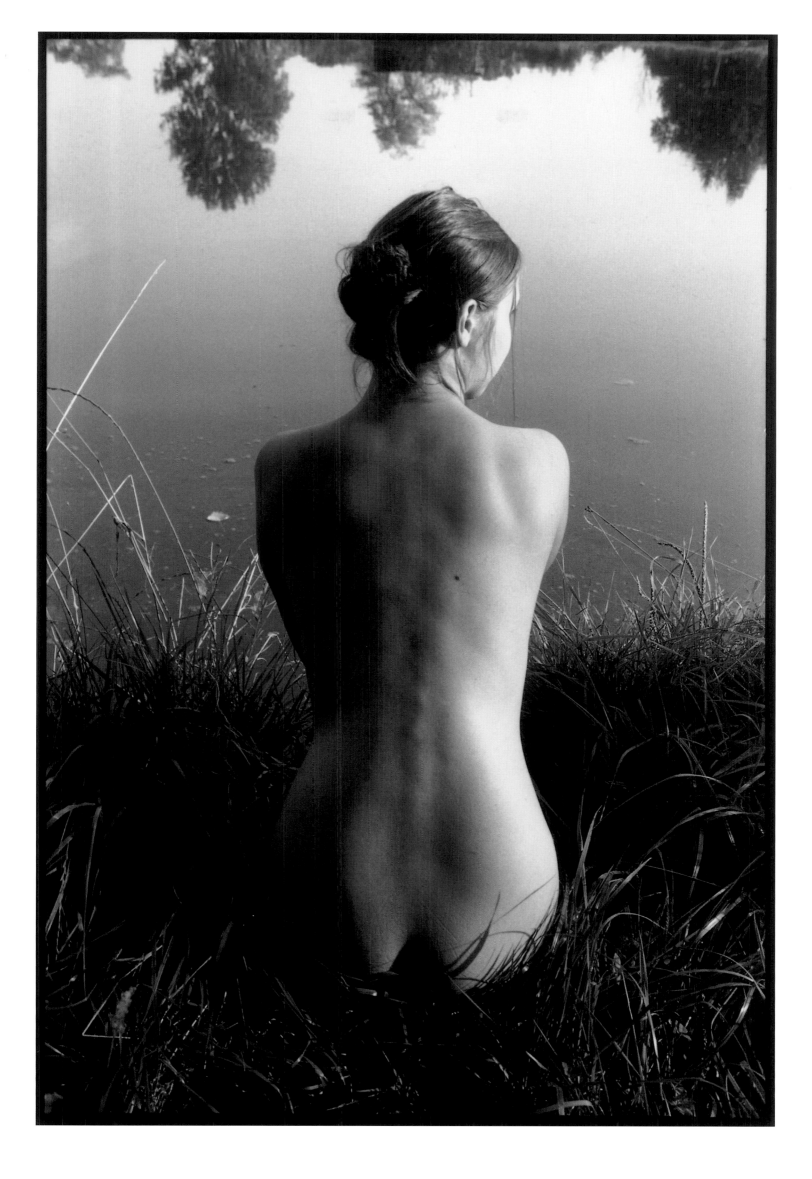

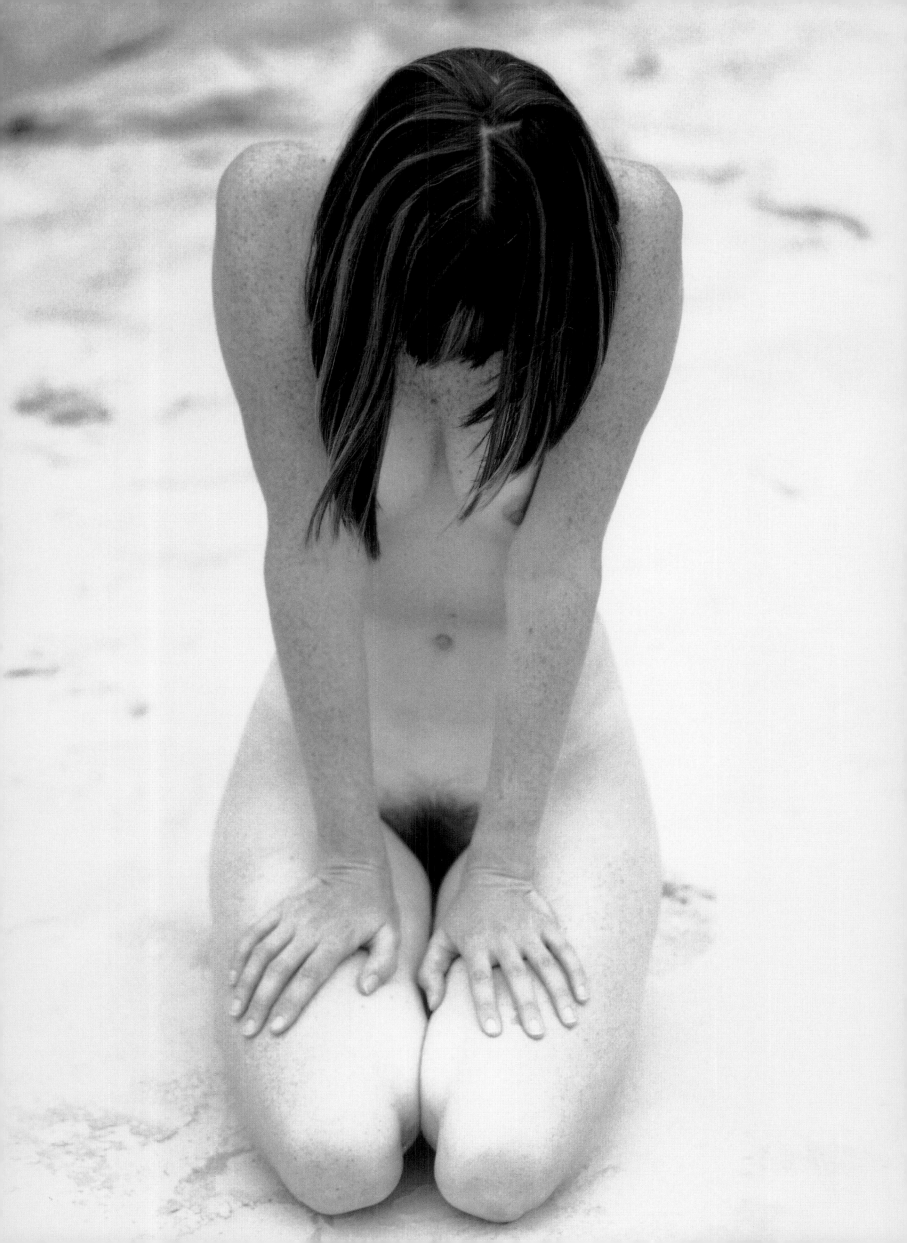

42

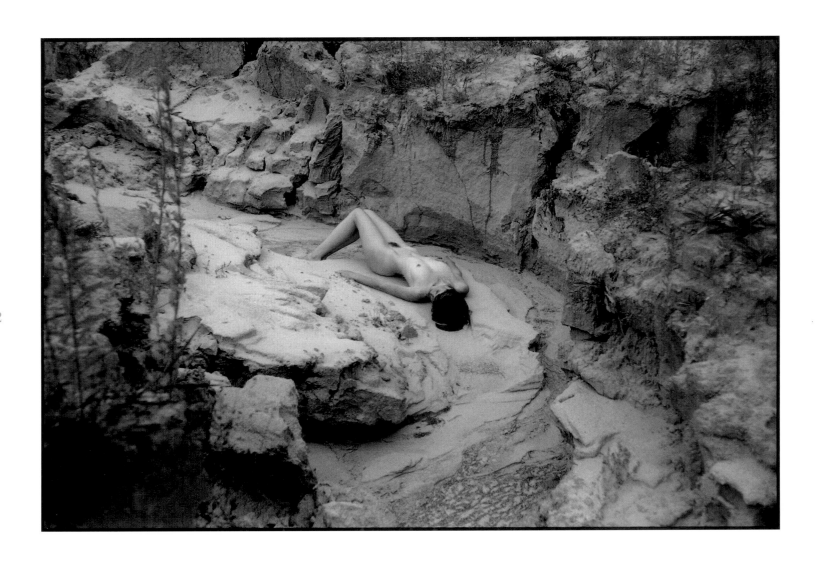

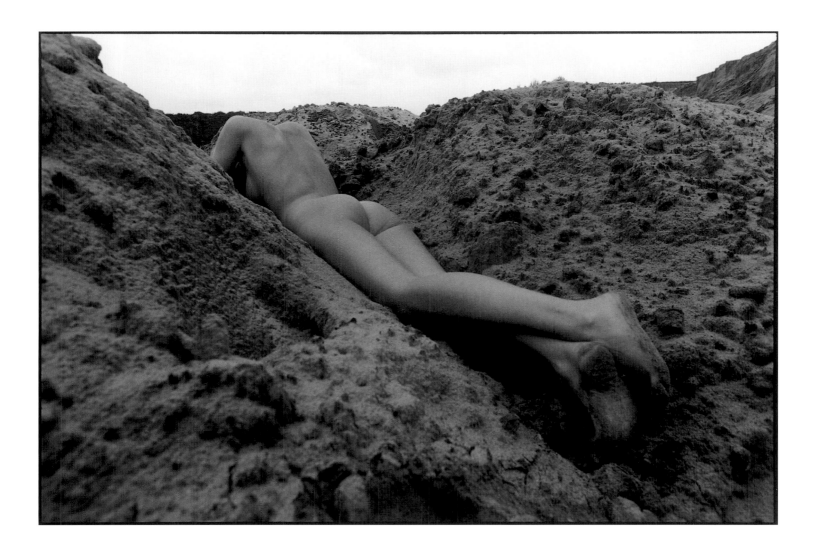

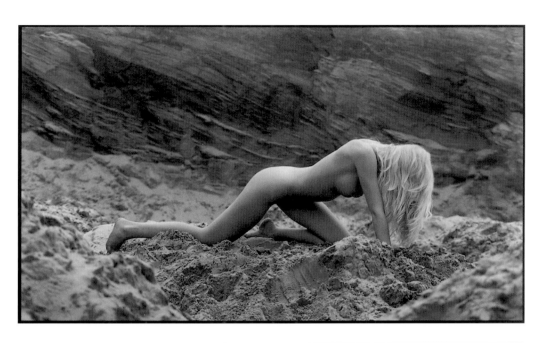

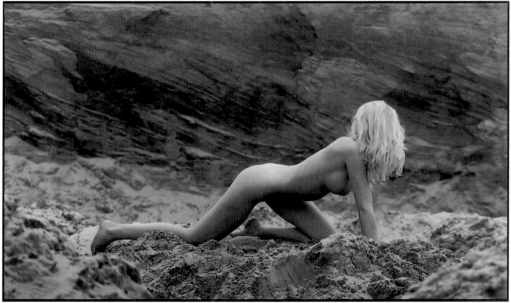

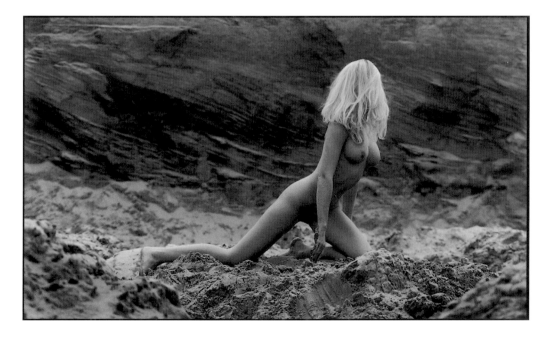

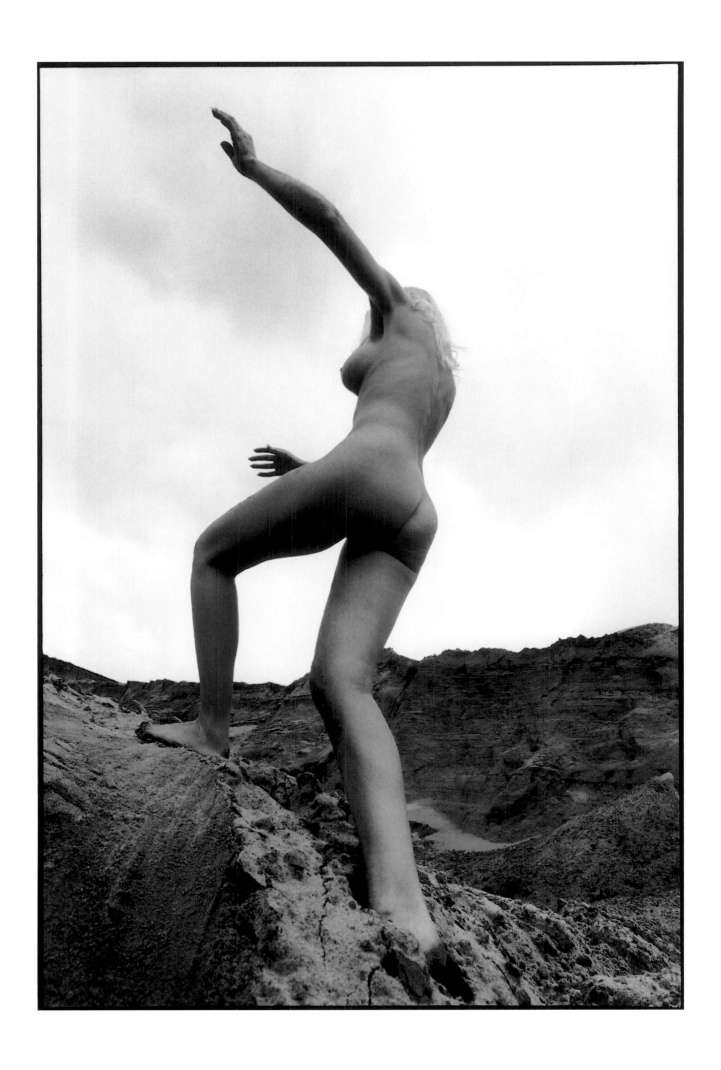

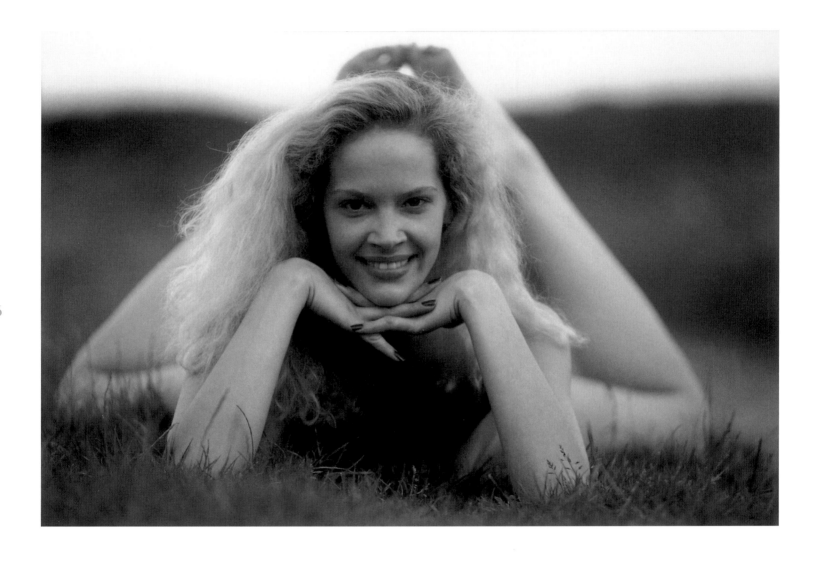

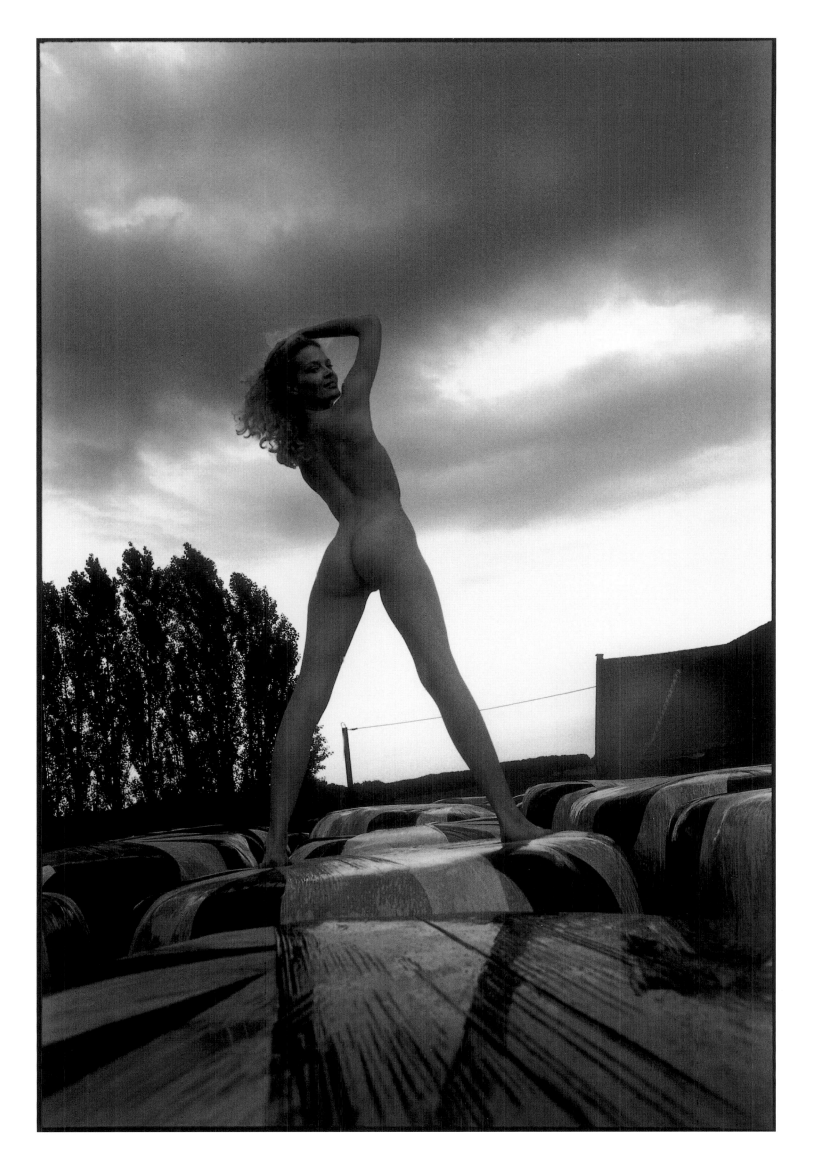

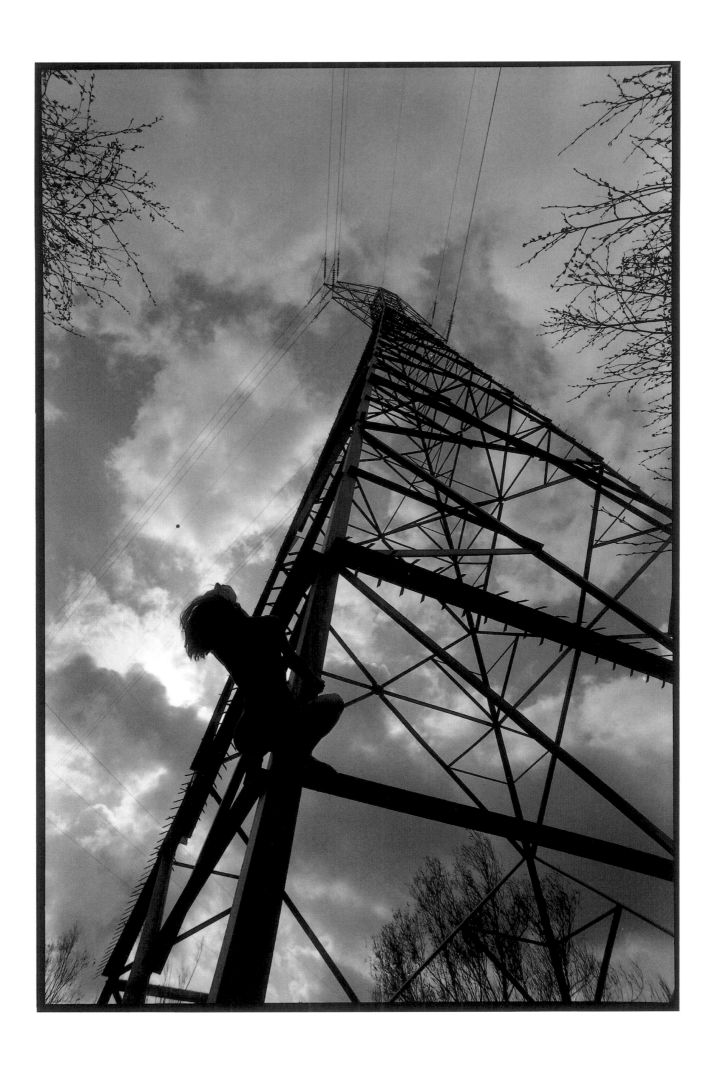

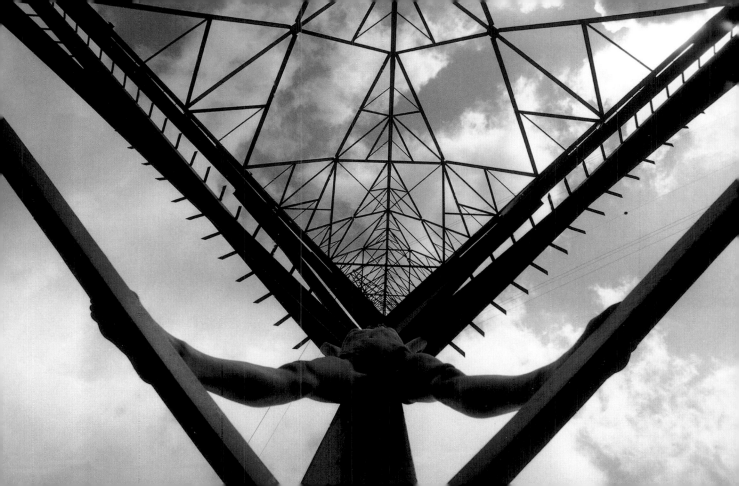

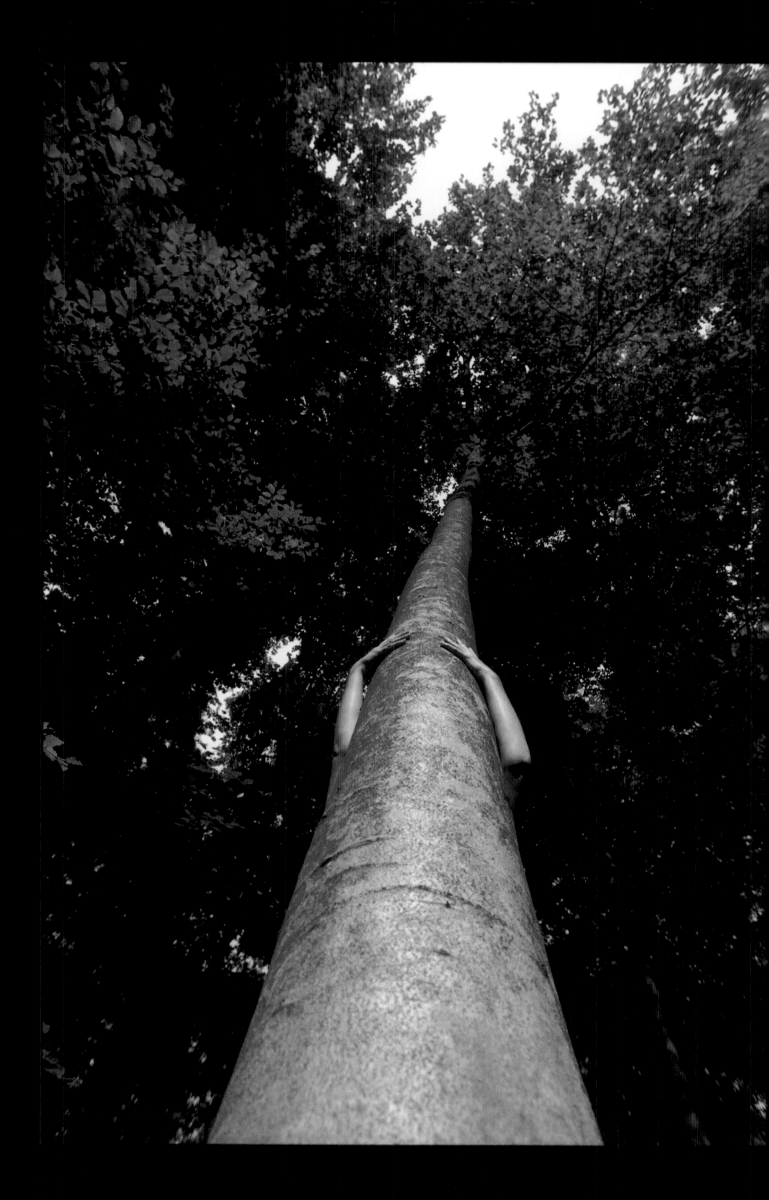

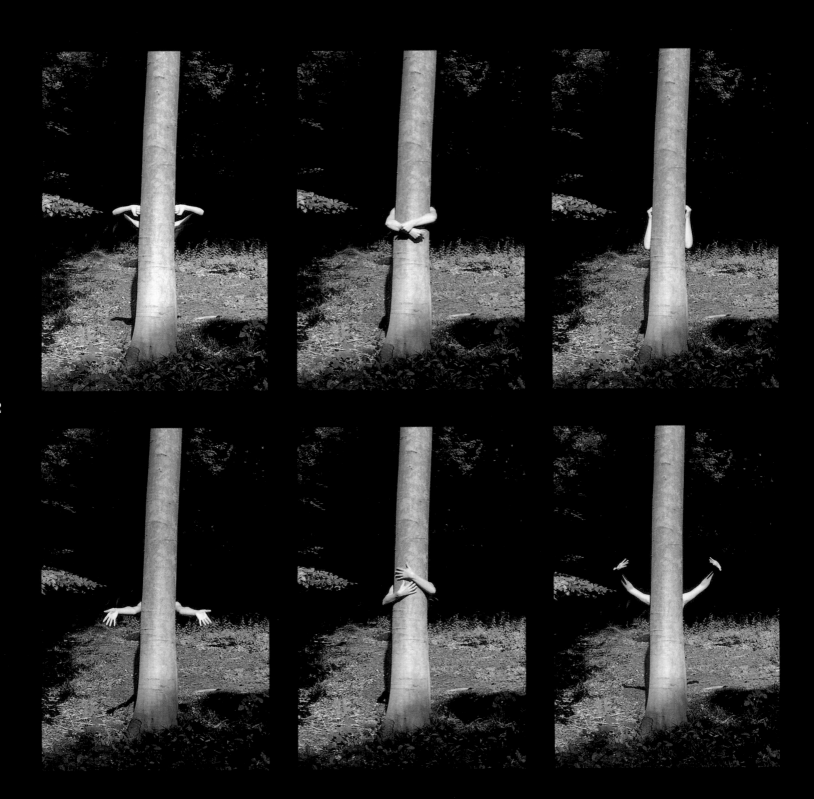

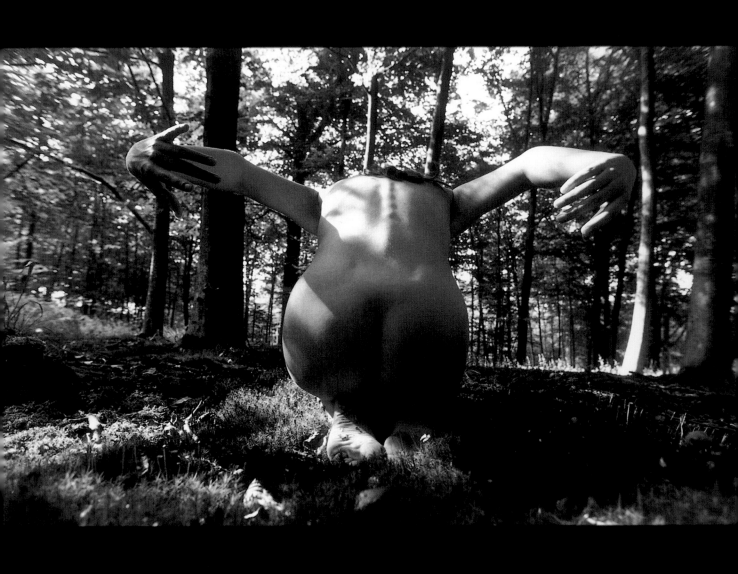

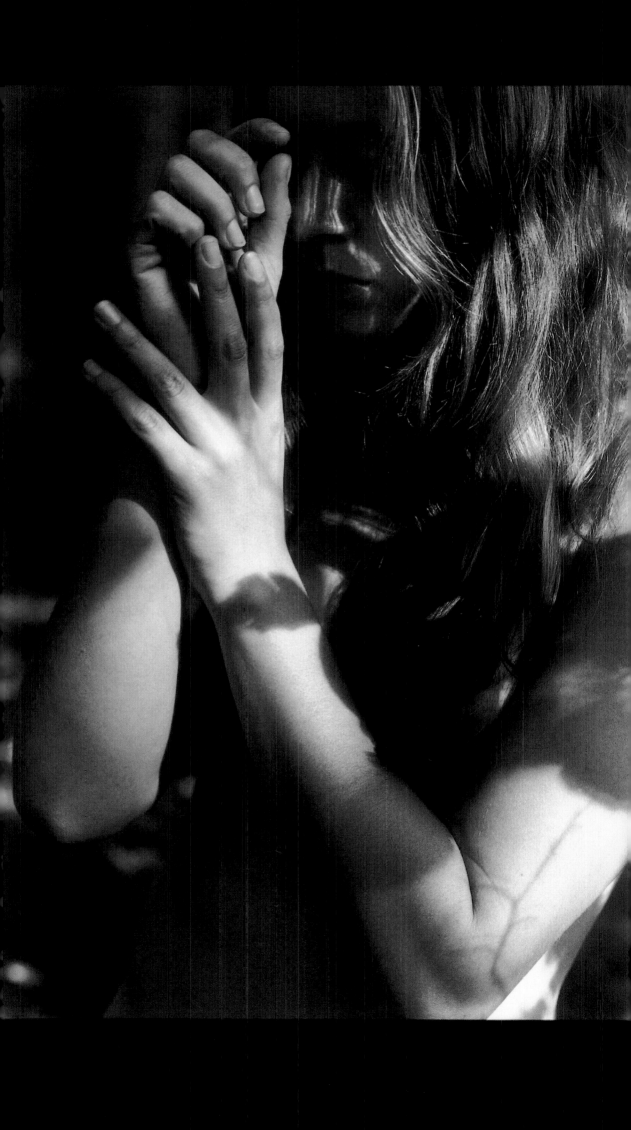

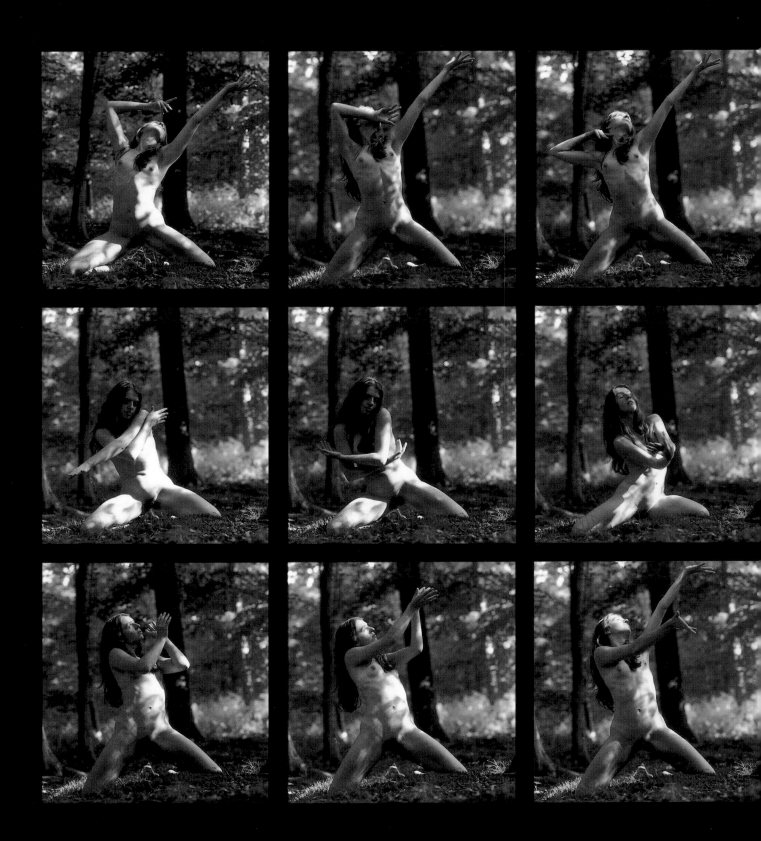

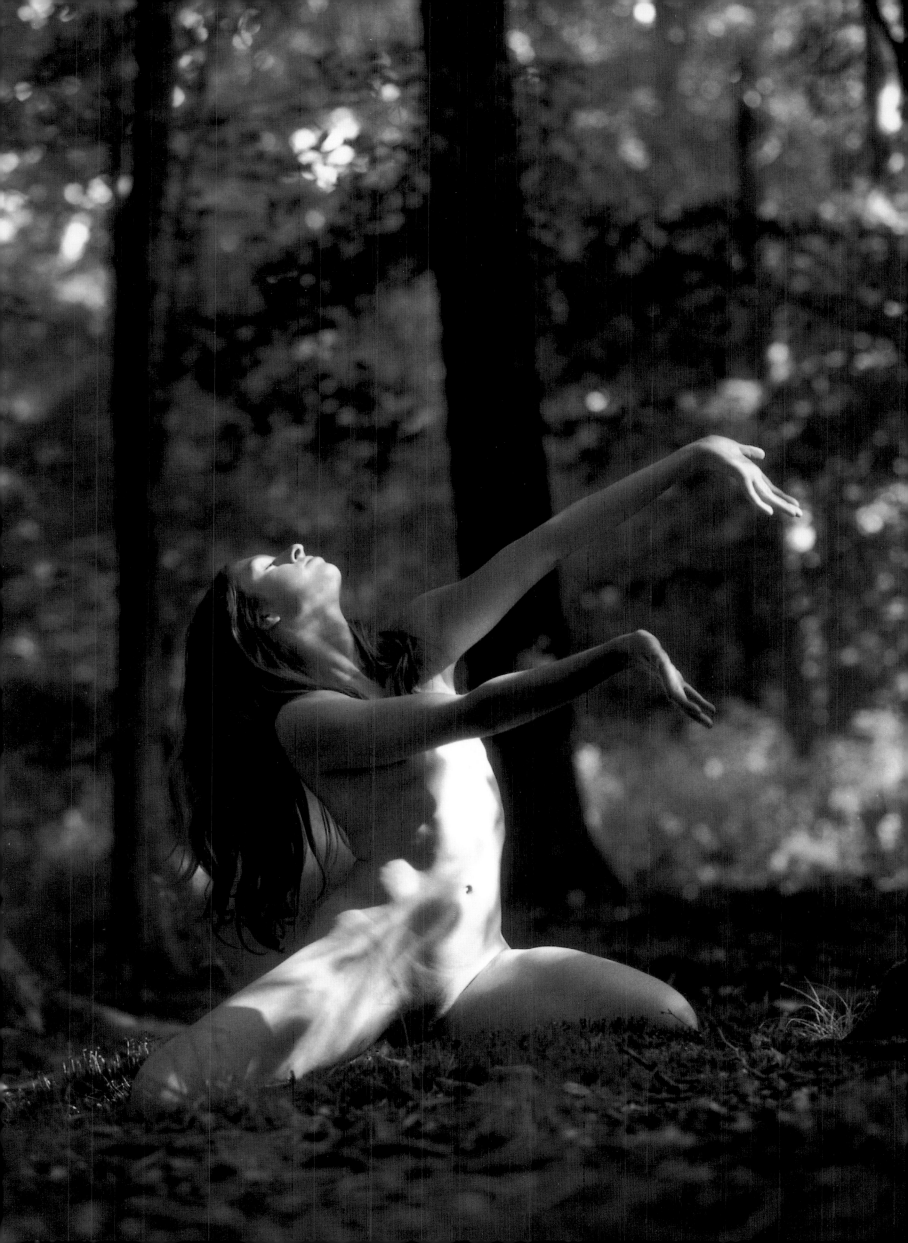

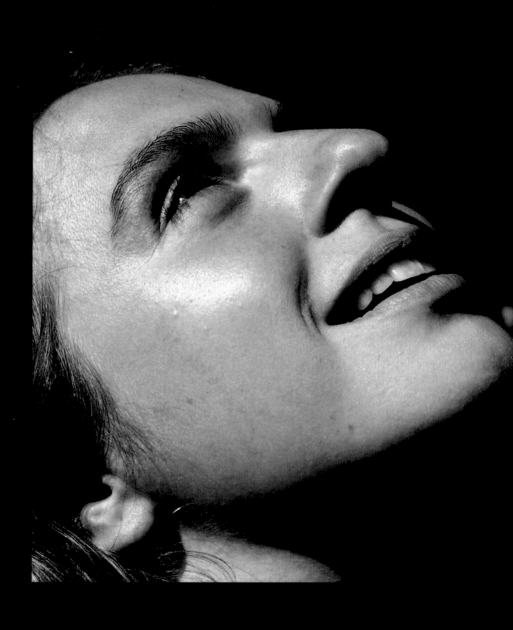

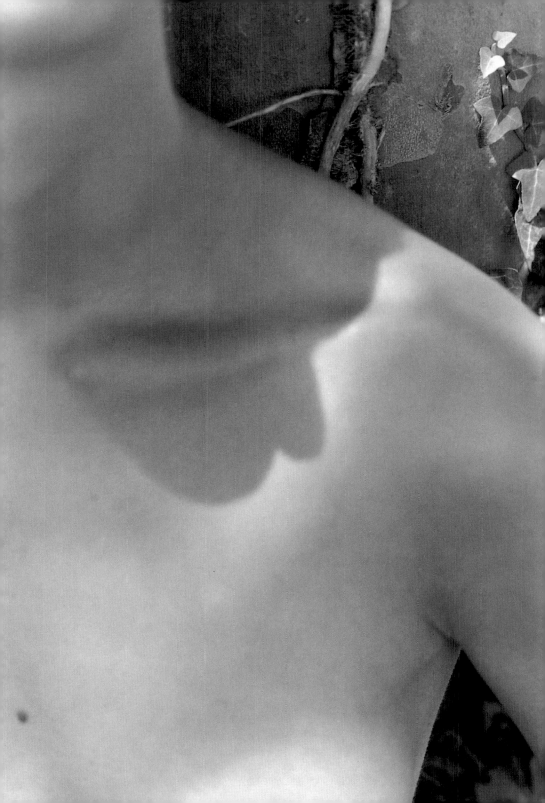

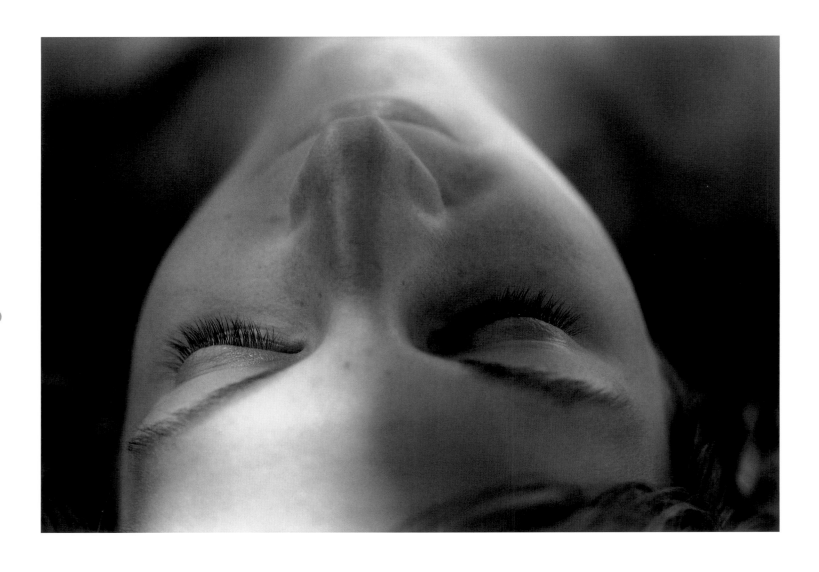

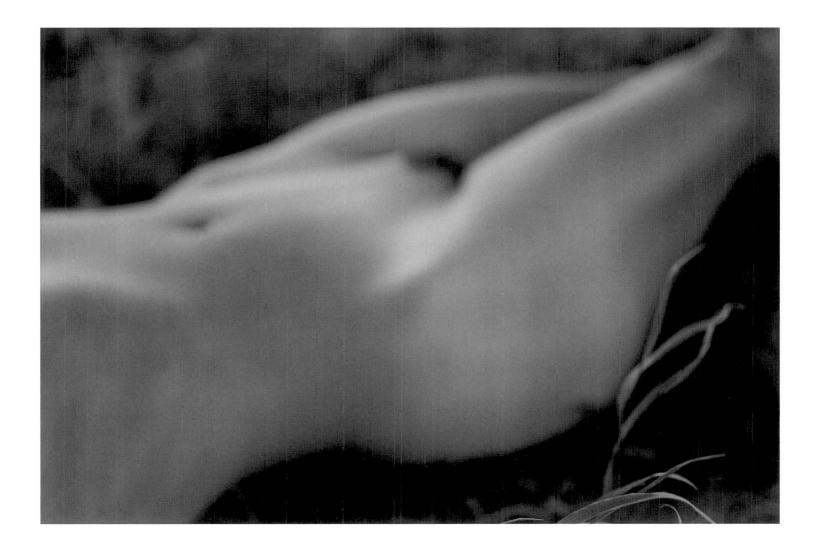

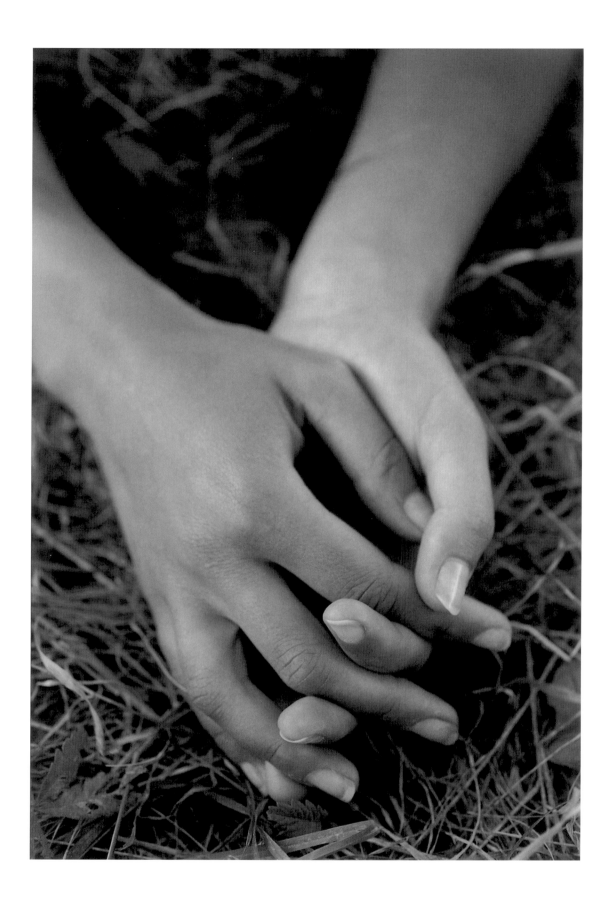

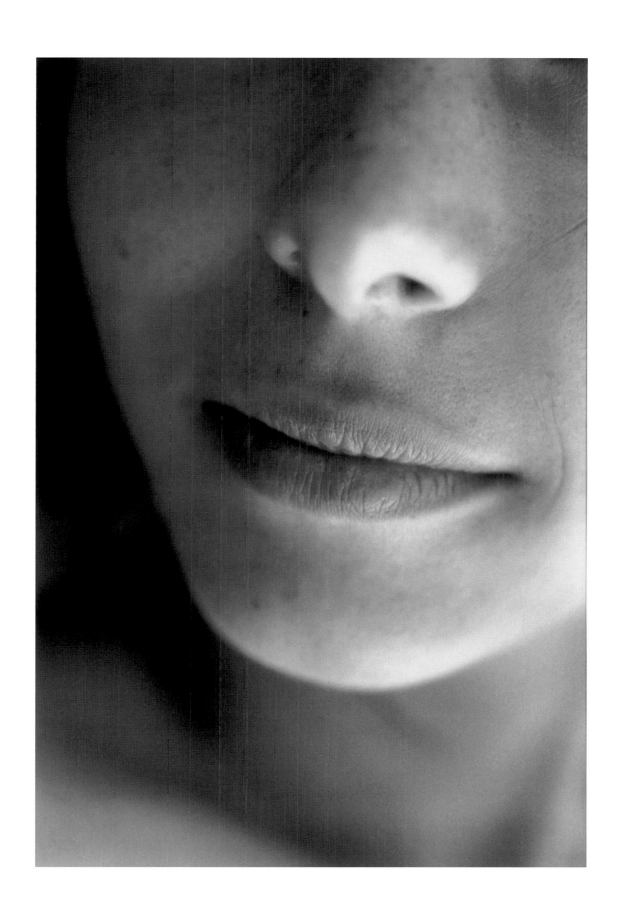

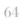64

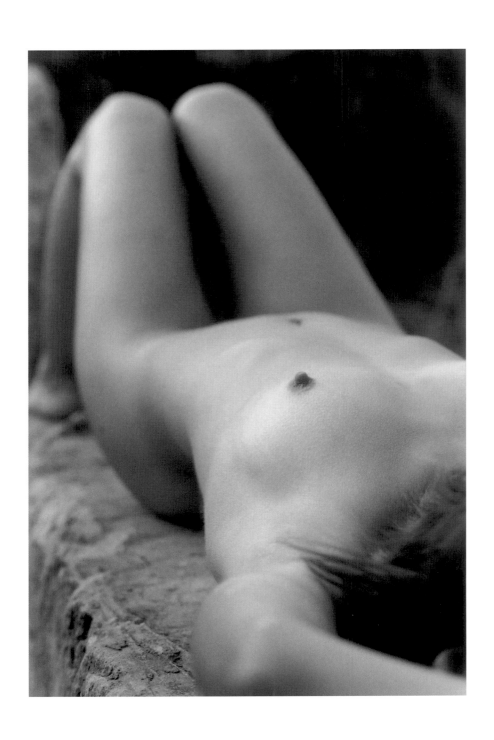

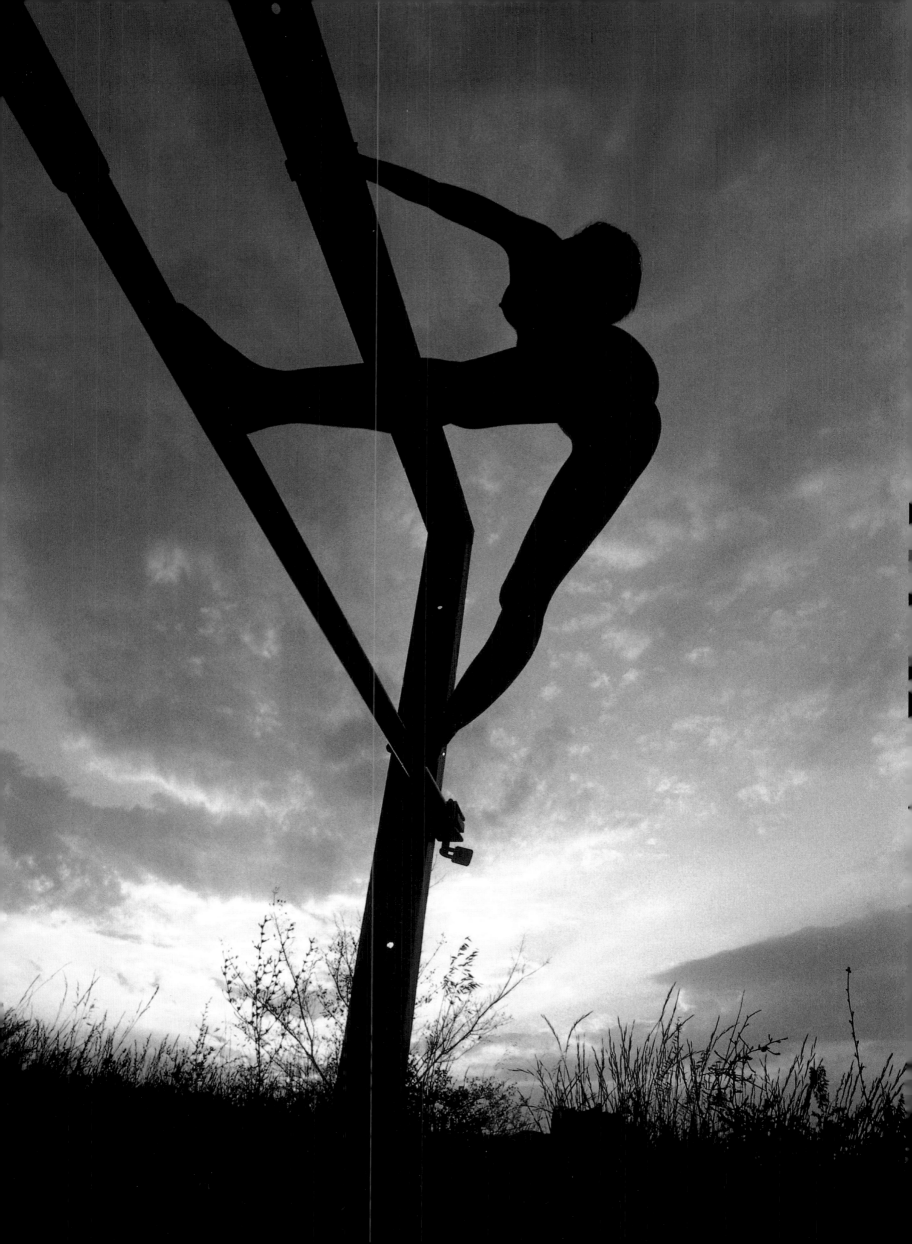

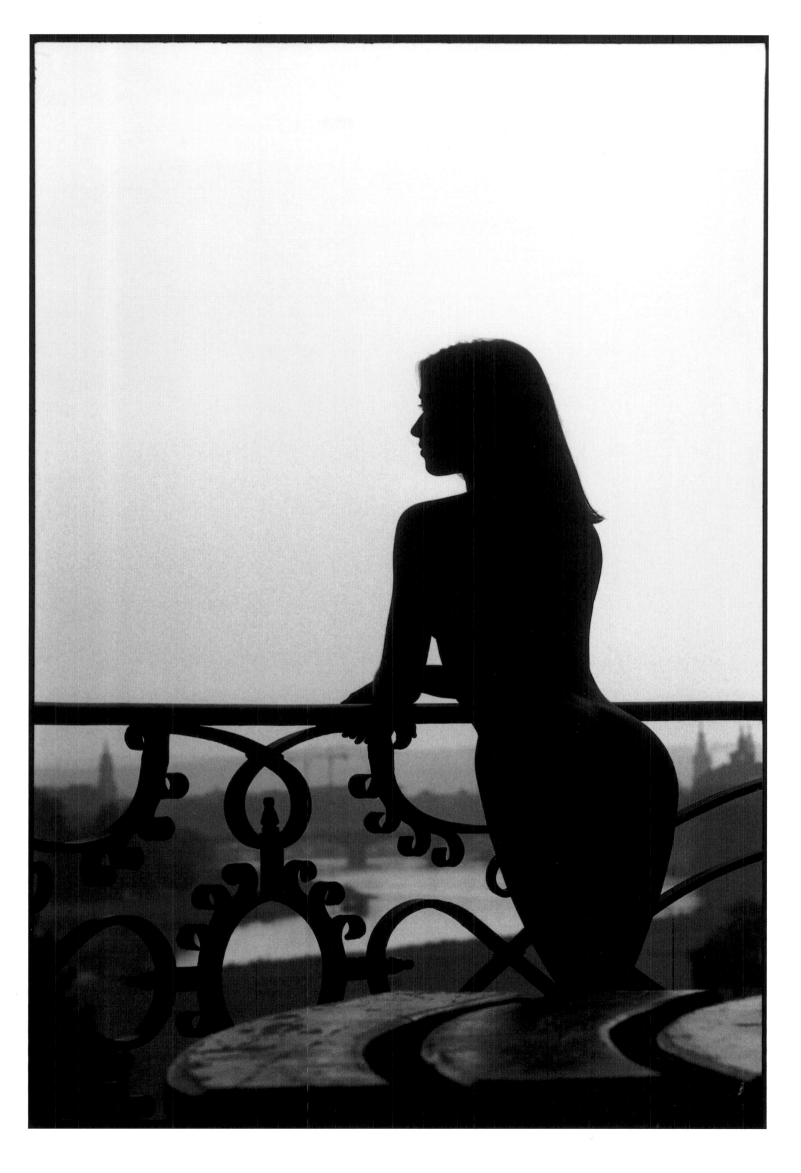

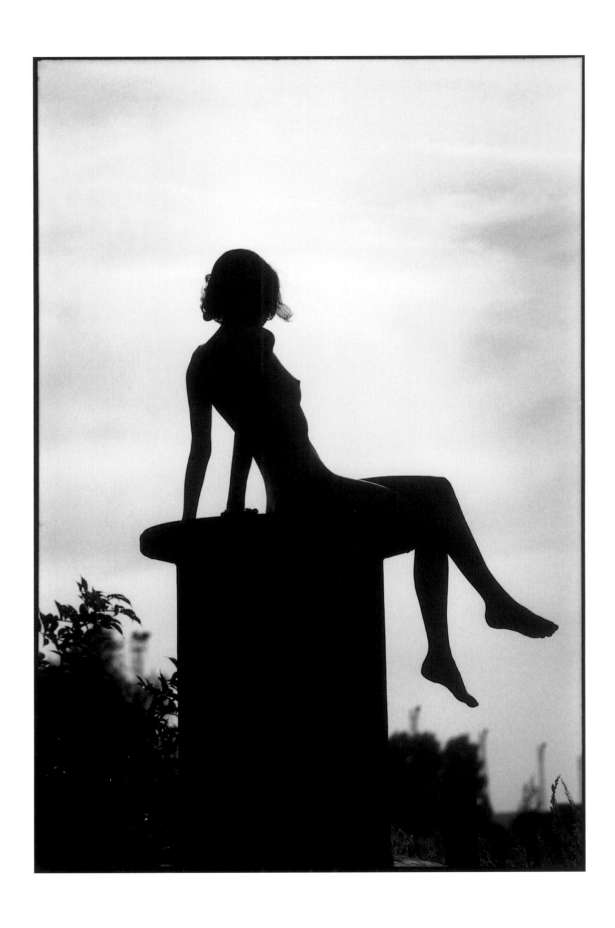

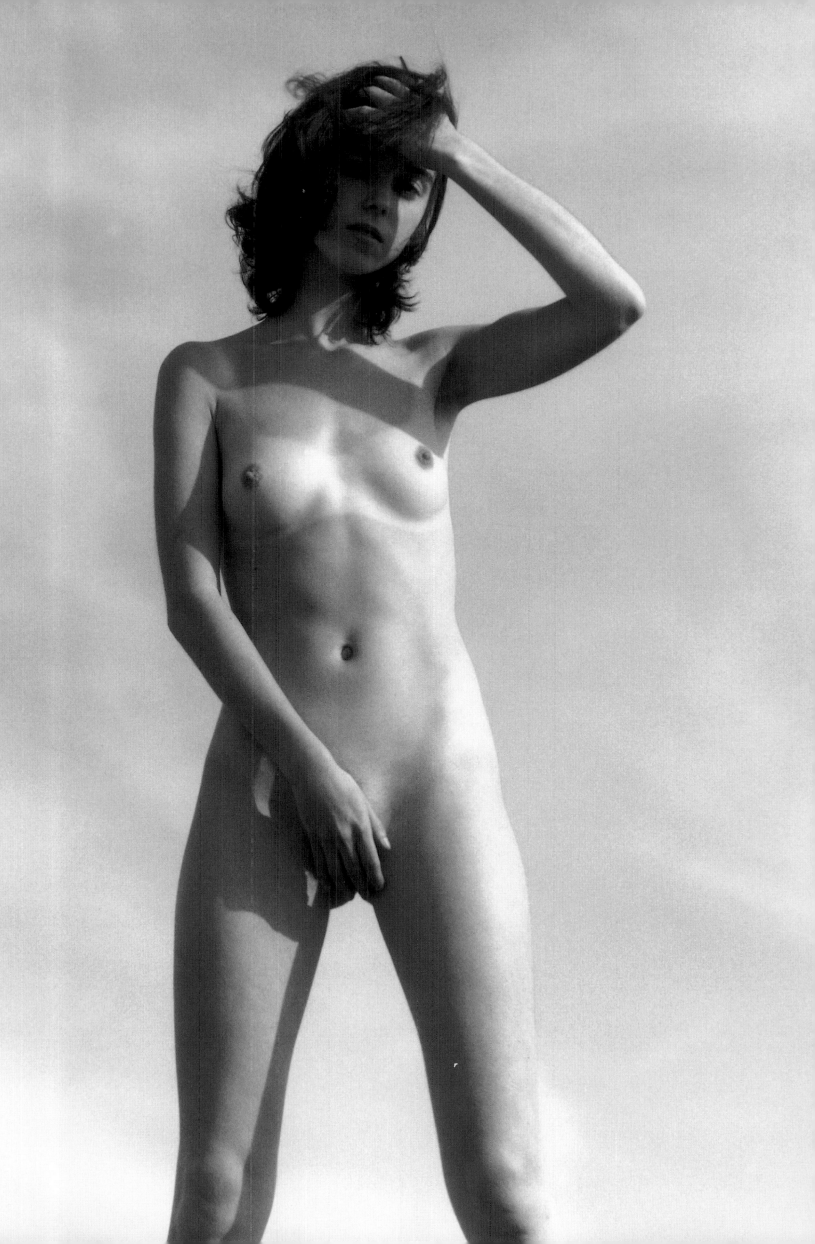

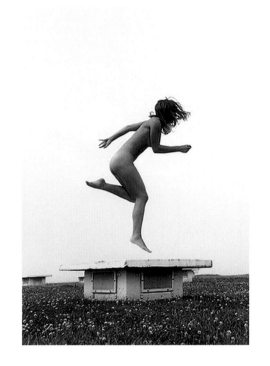
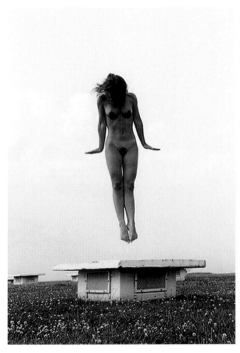
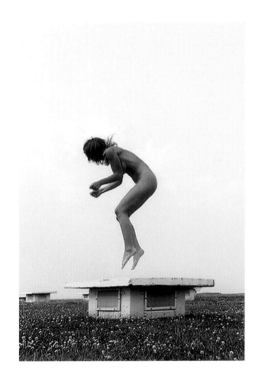

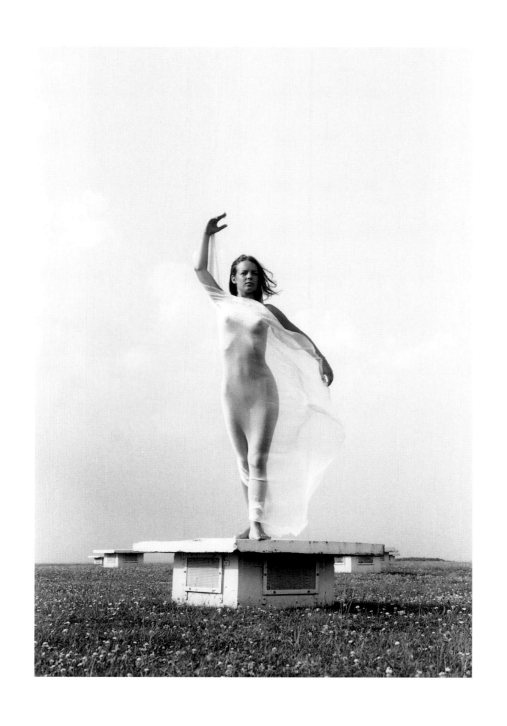

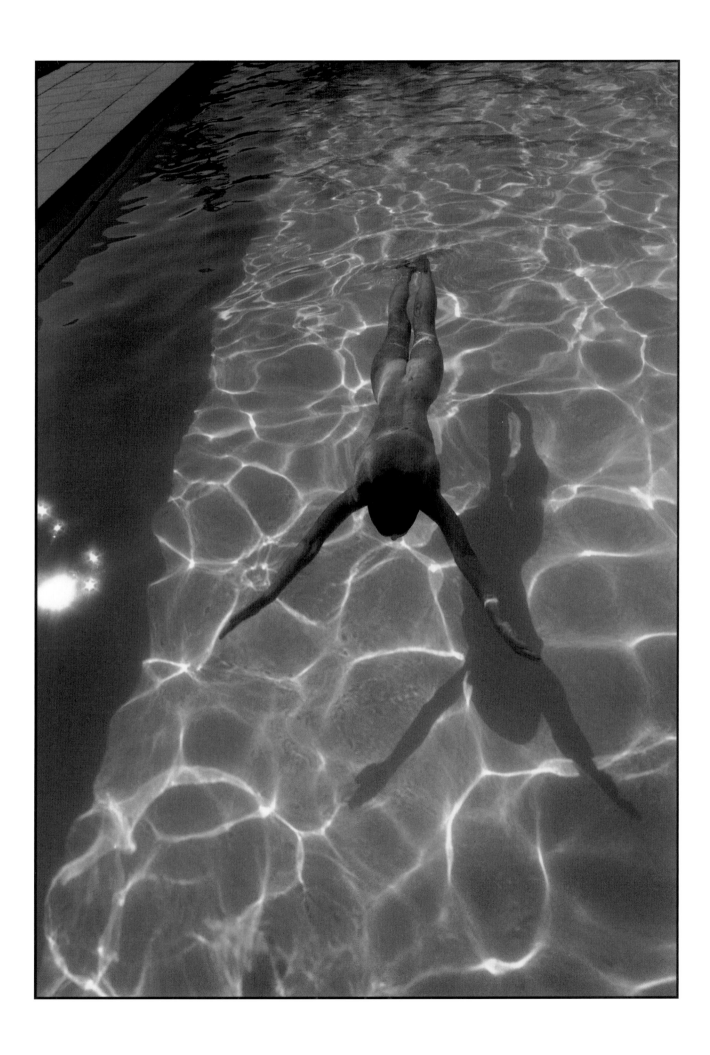

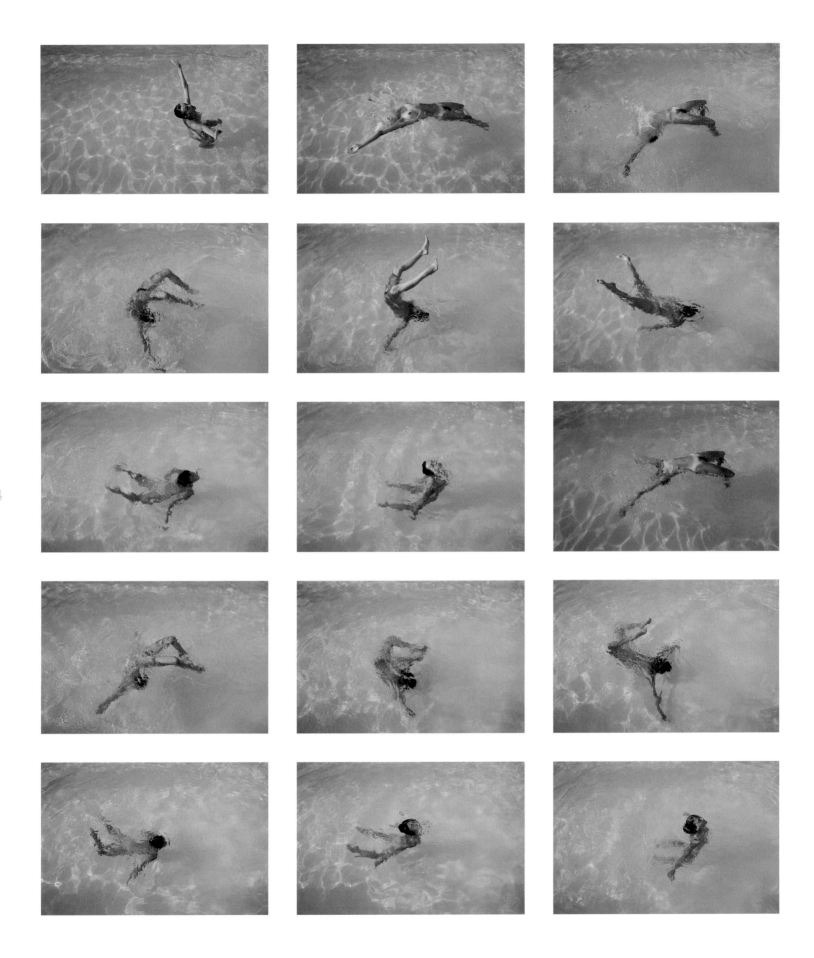

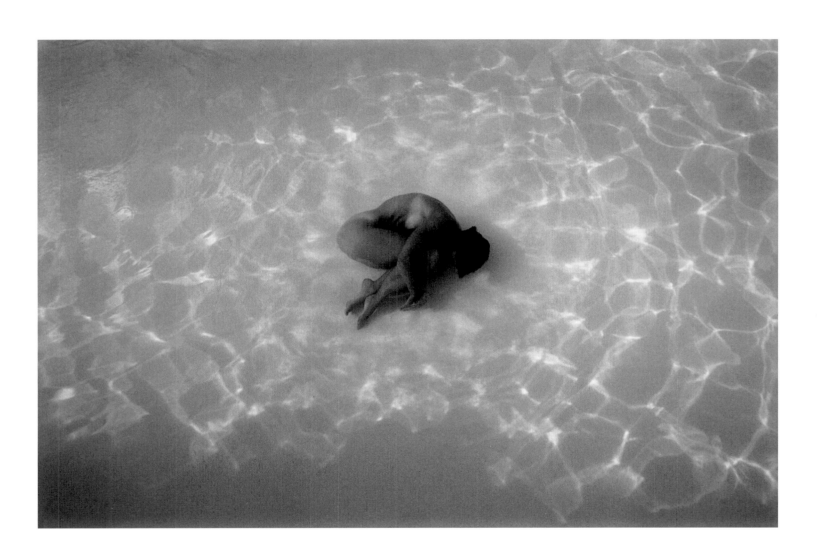

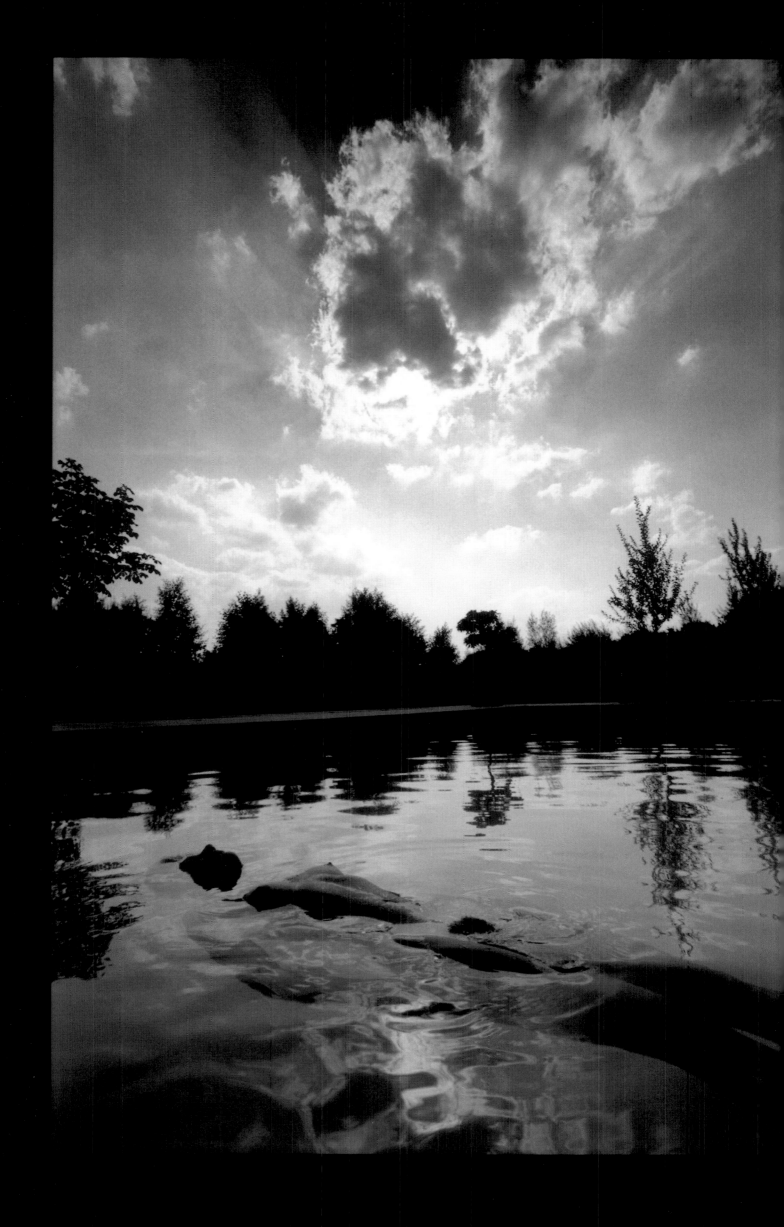

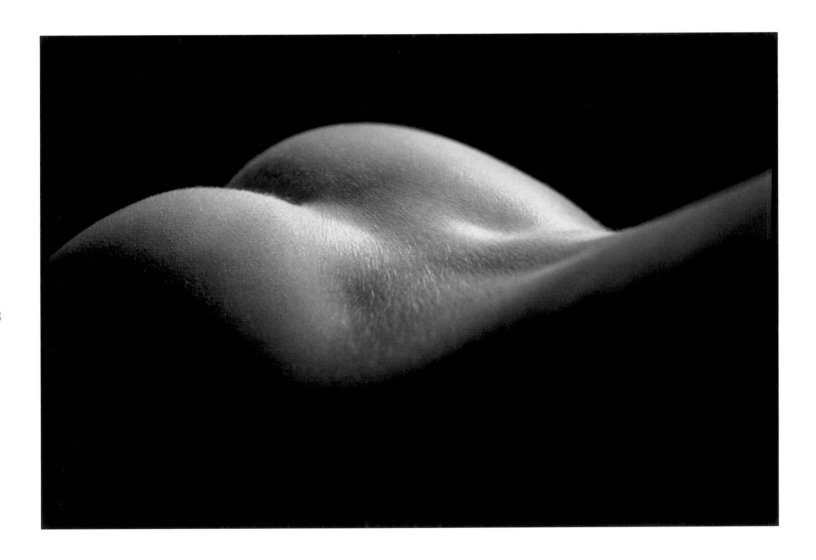

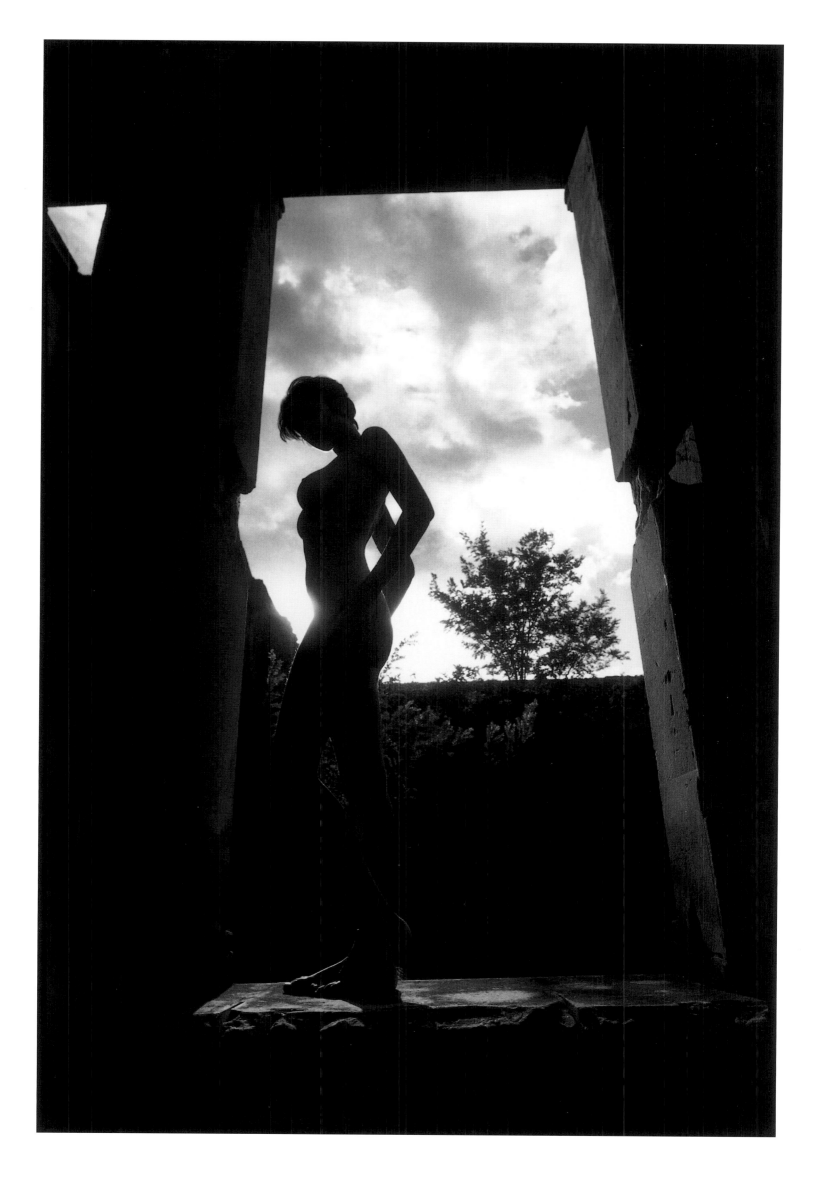

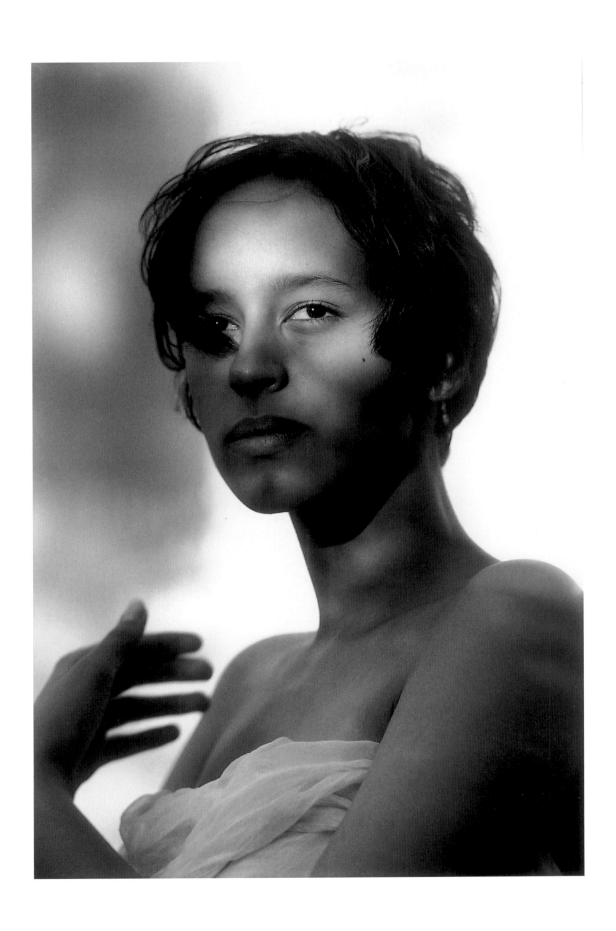

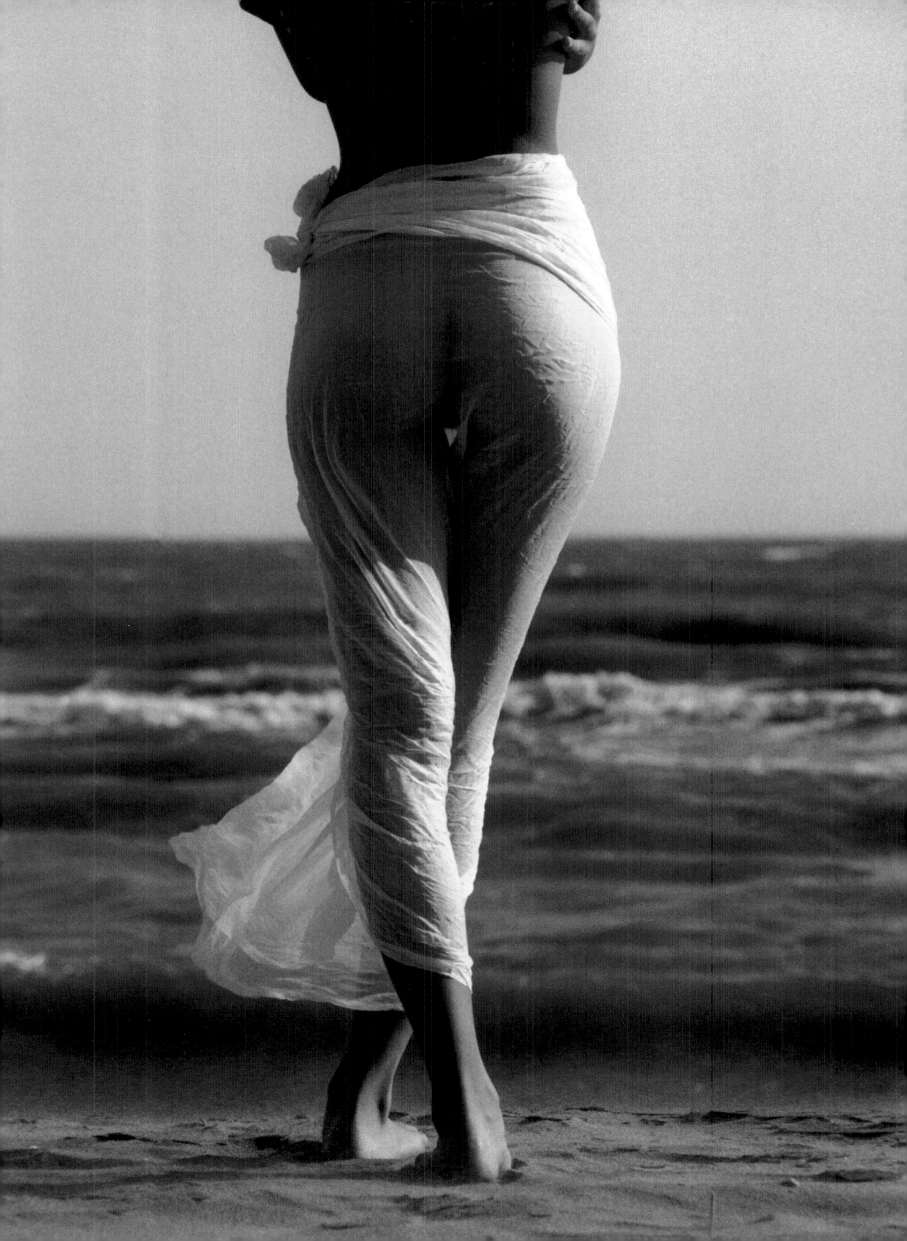

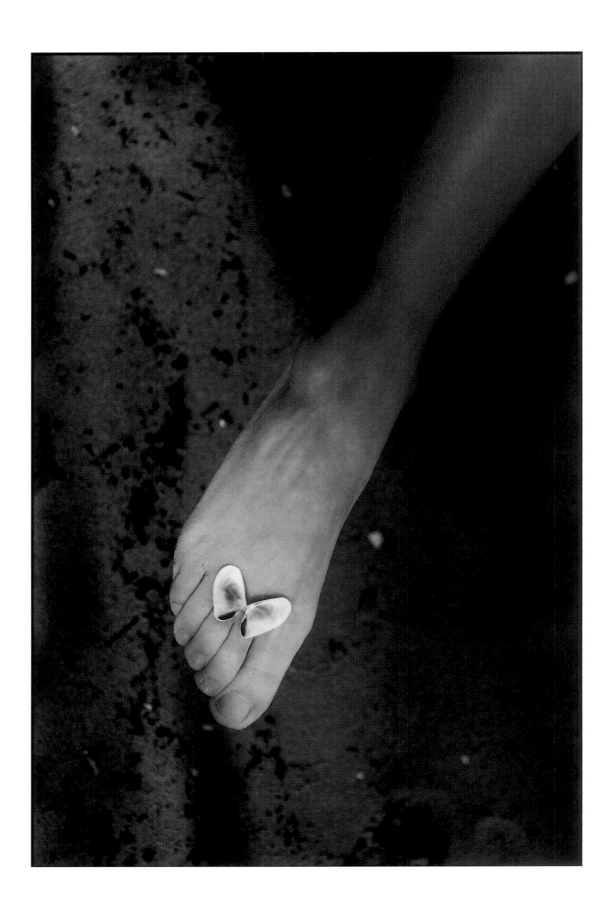

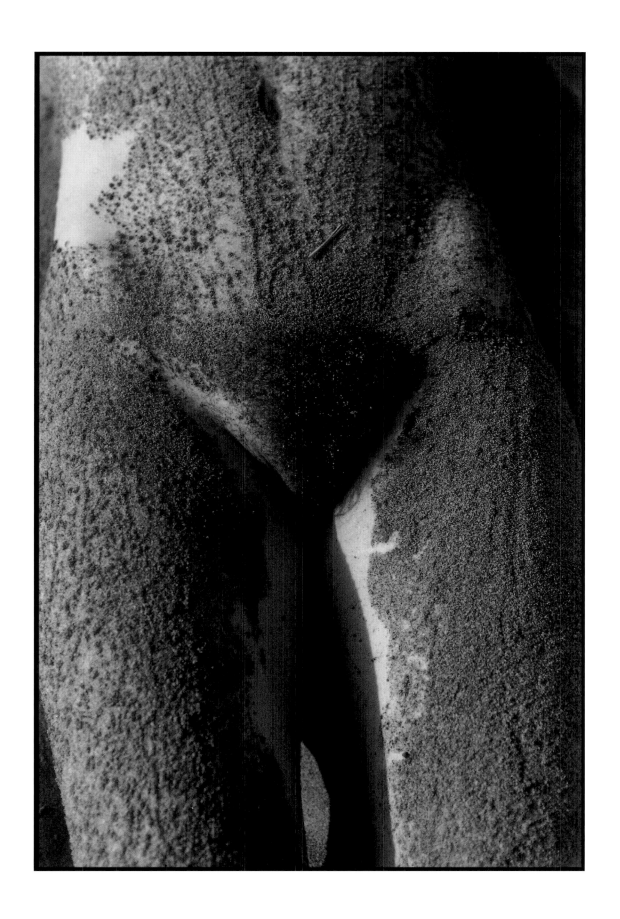

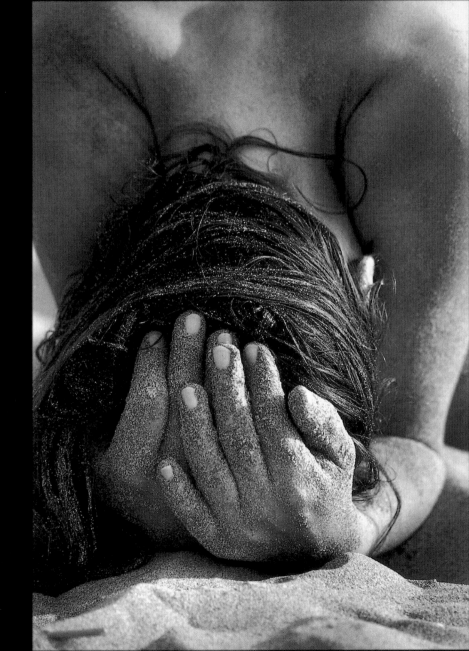

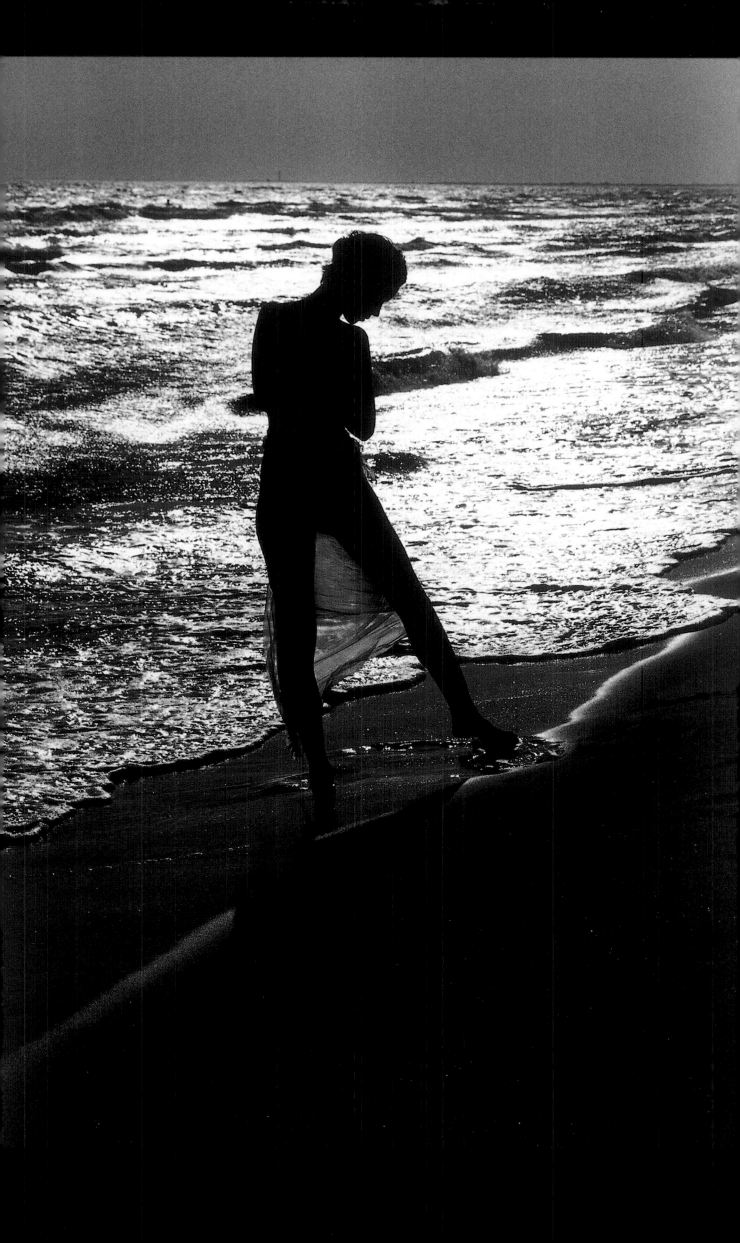

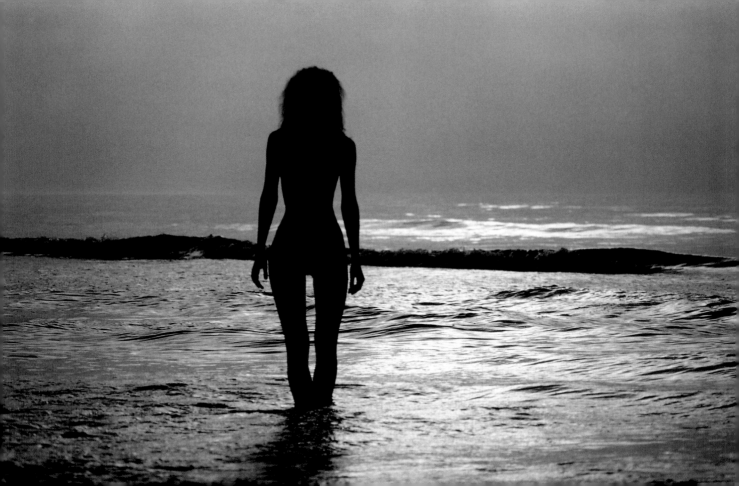

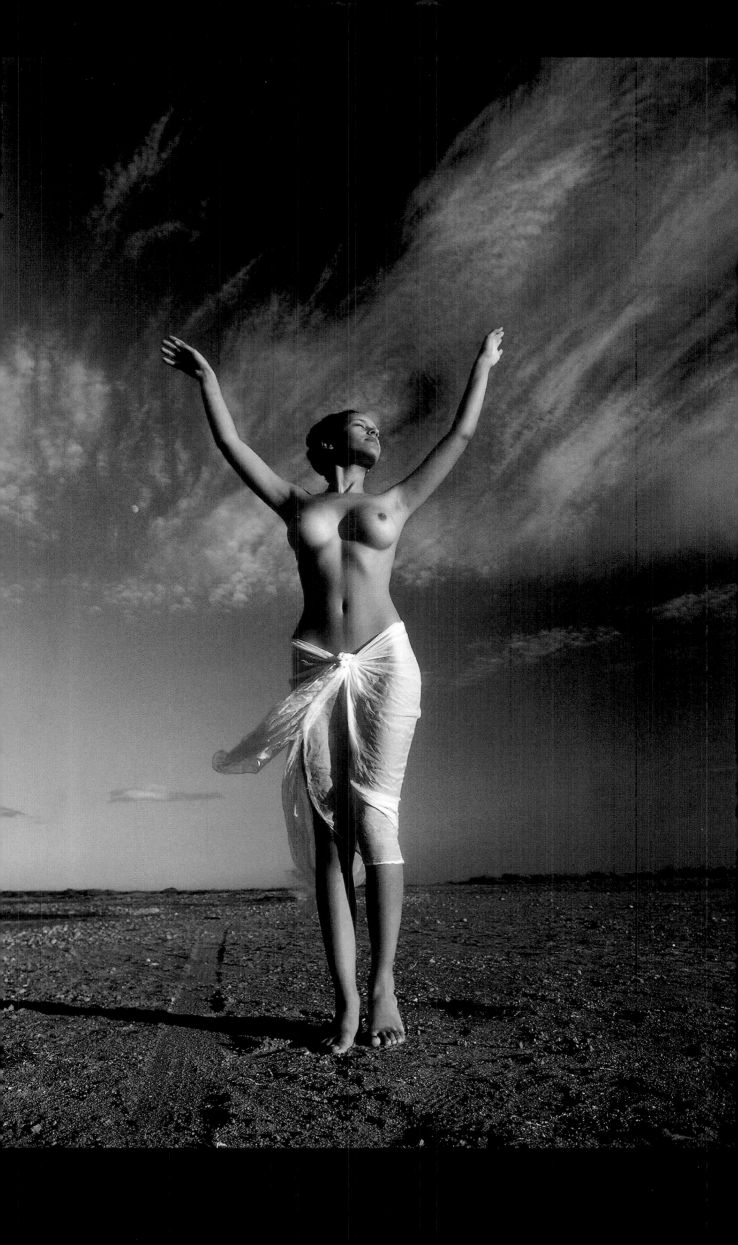

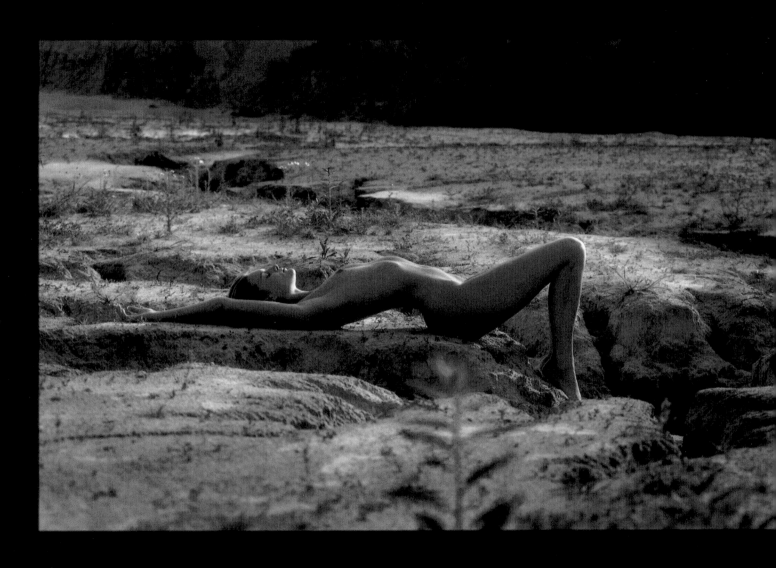

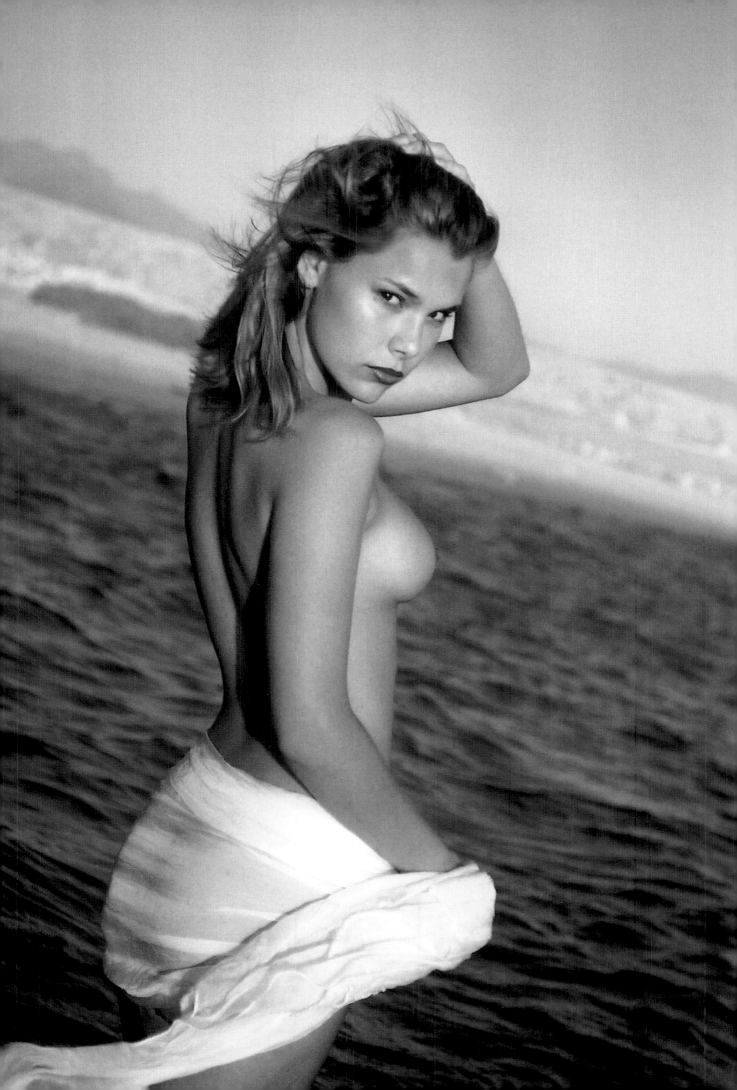

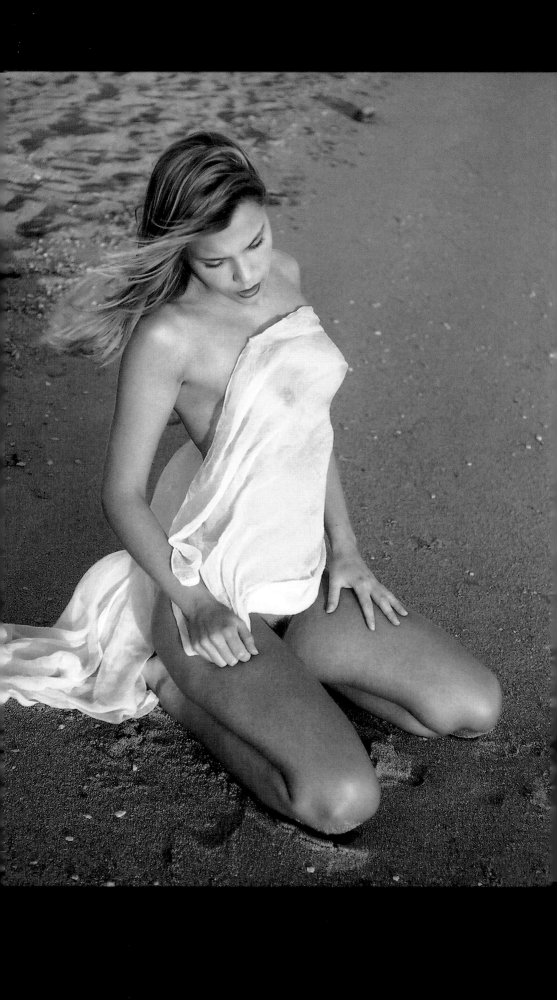

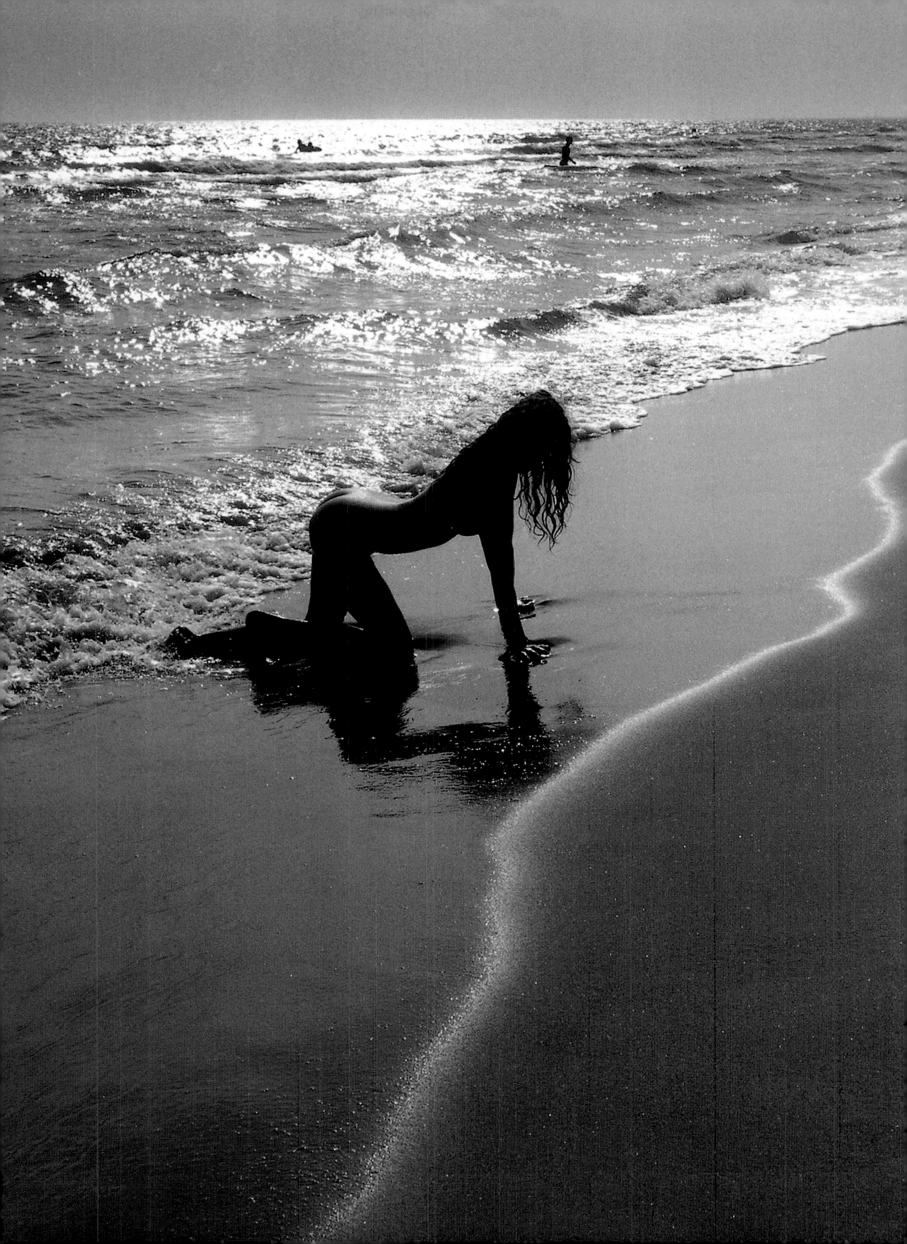

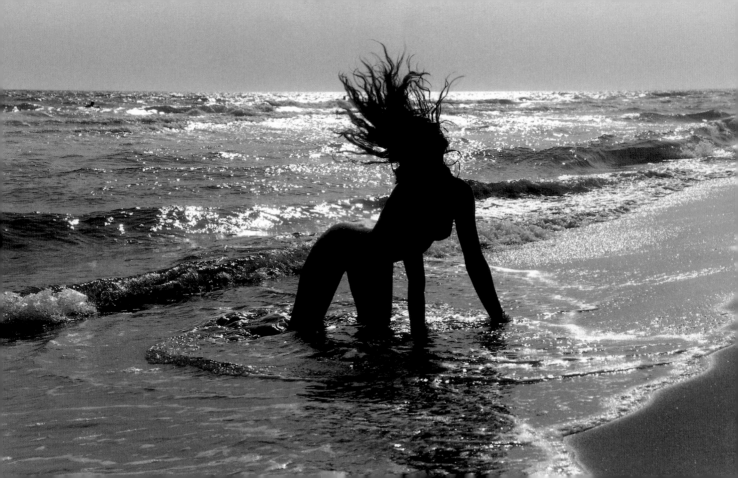

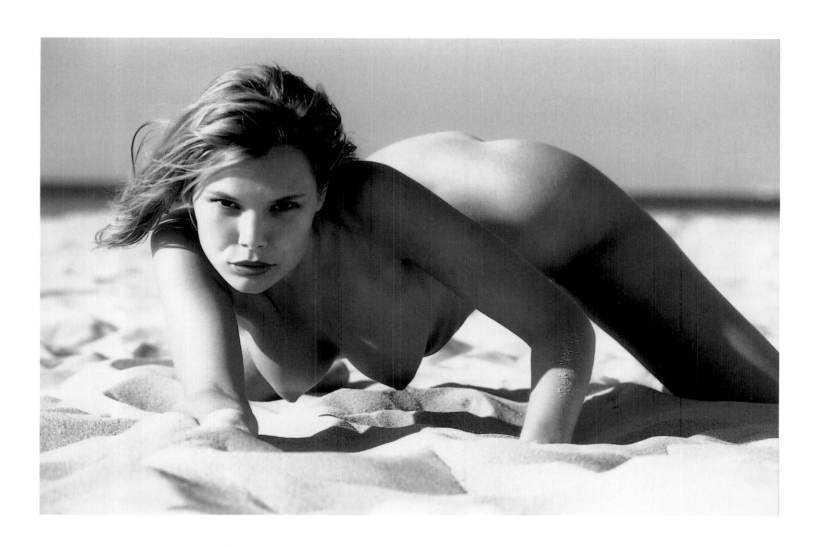

95

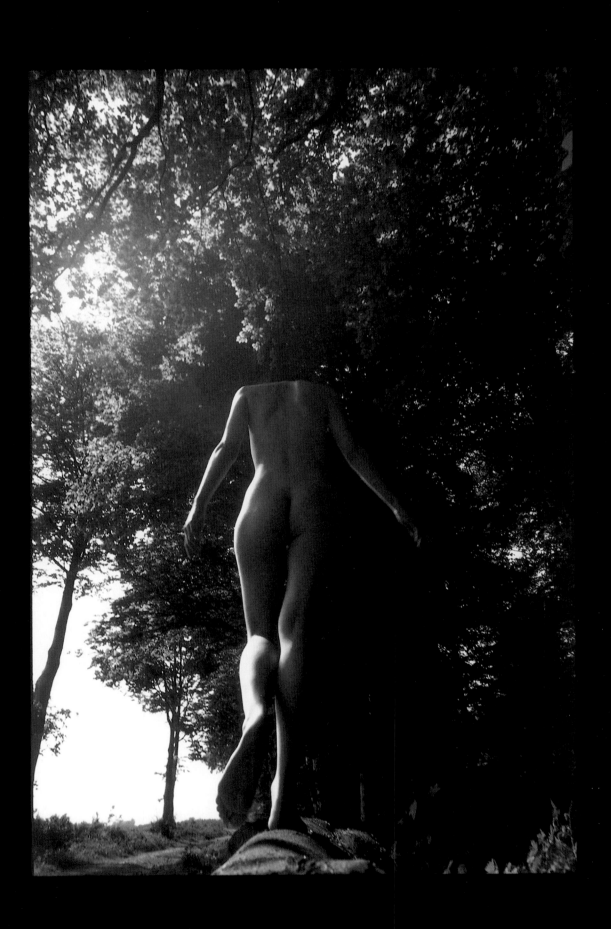

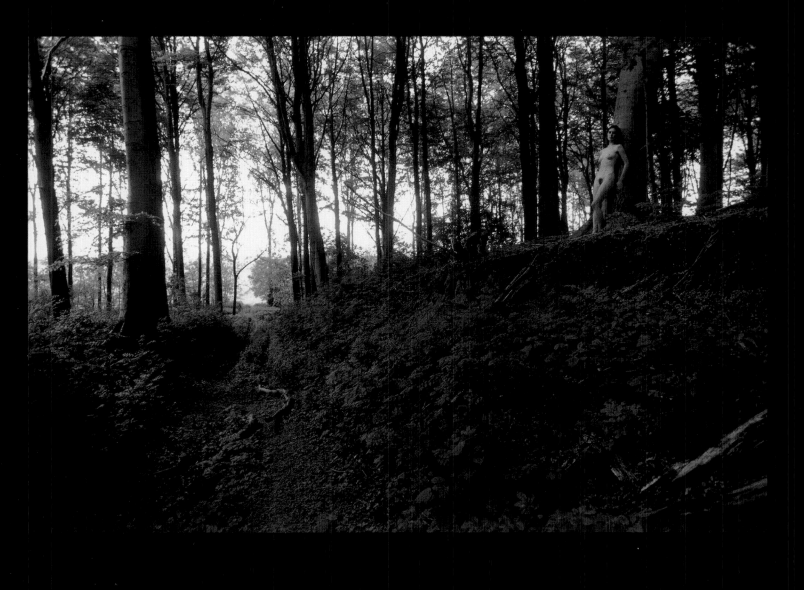

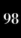

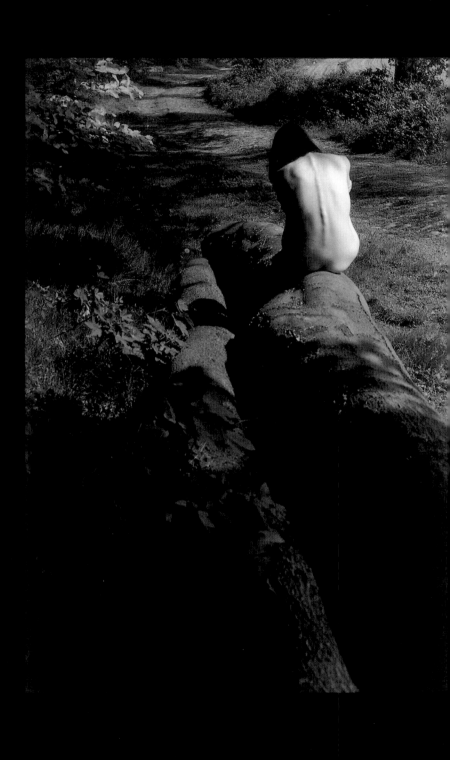

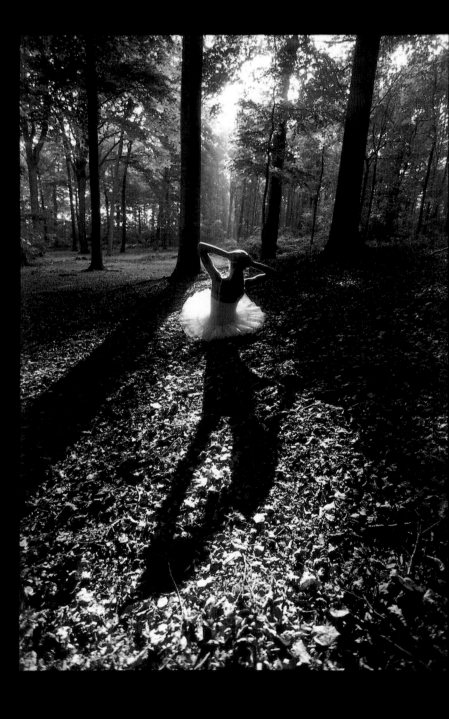

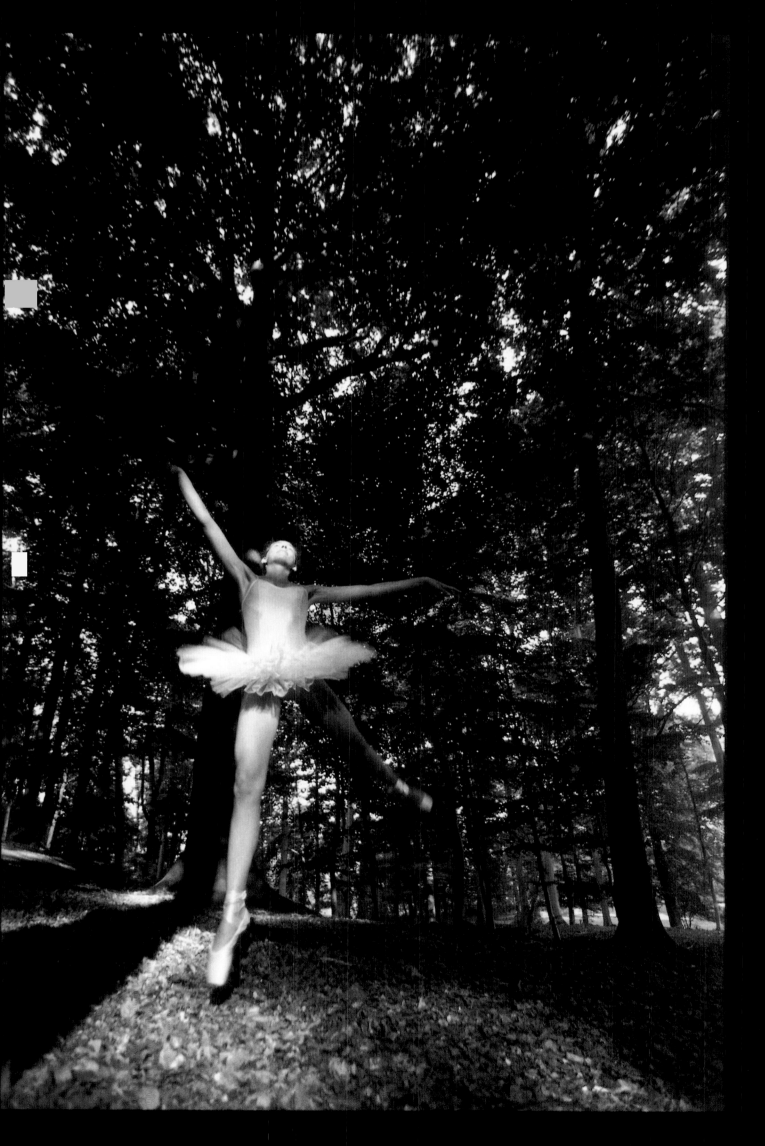

102

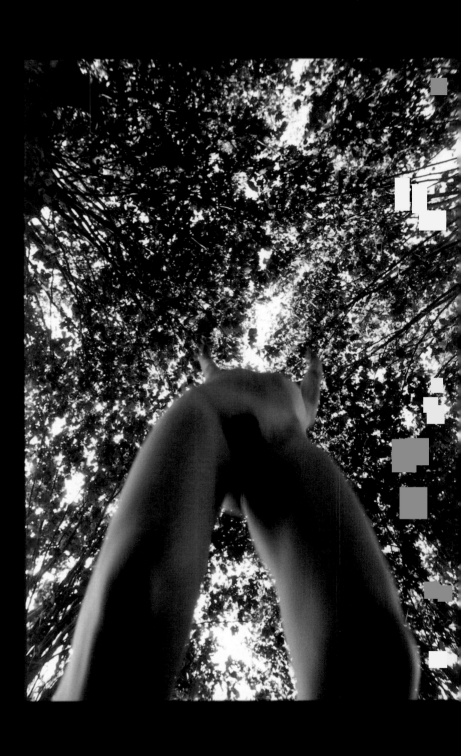

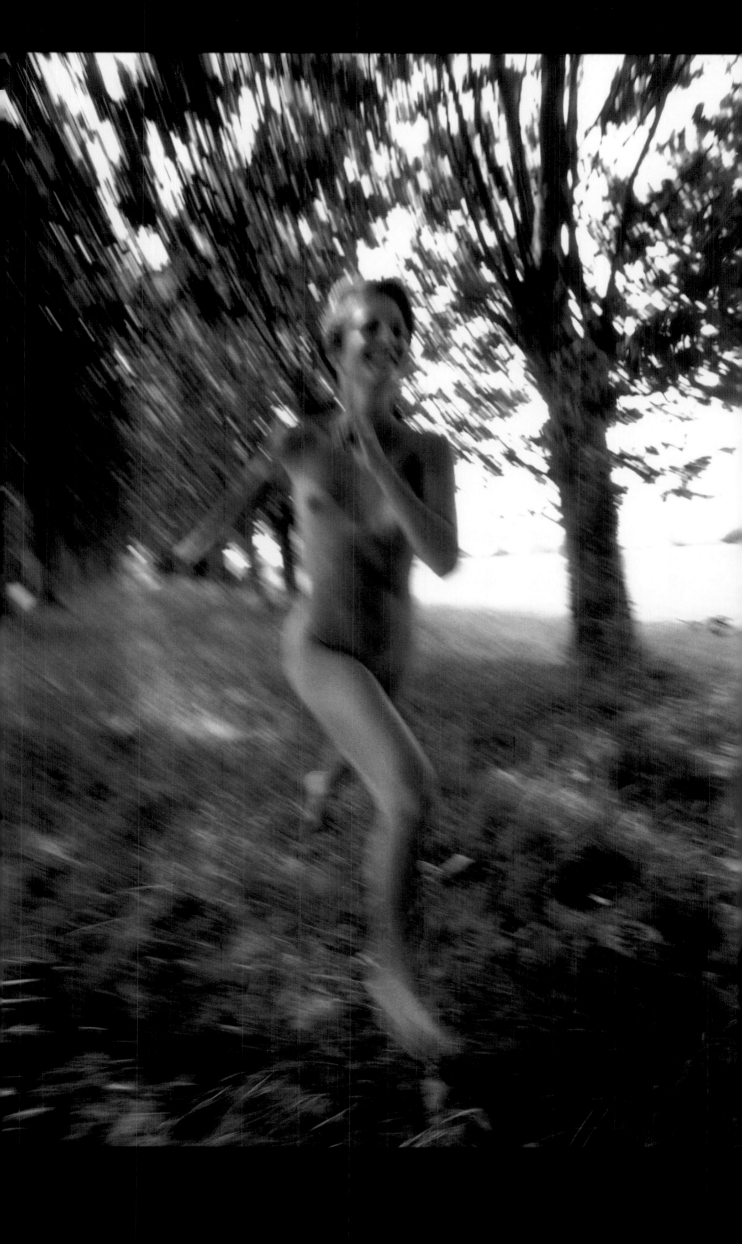

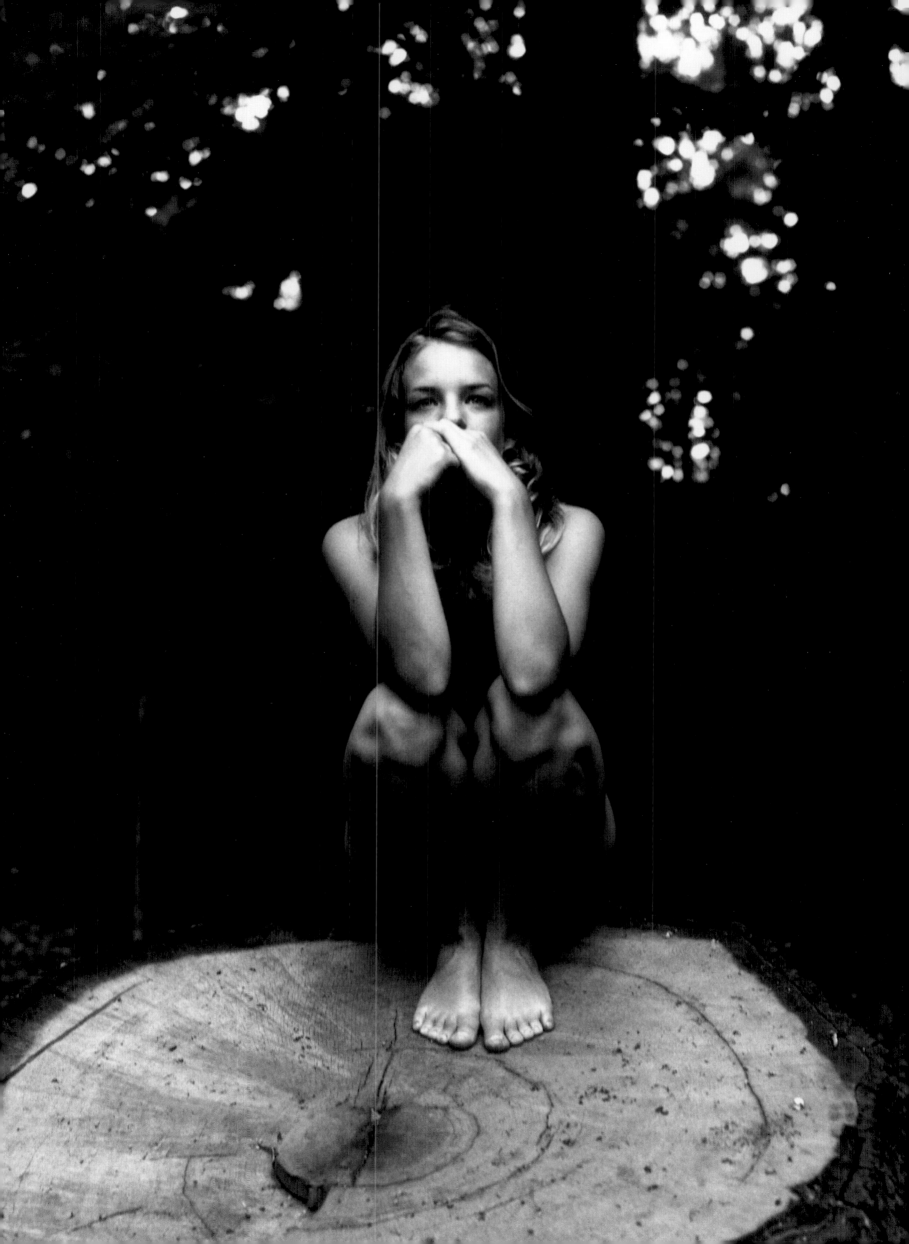

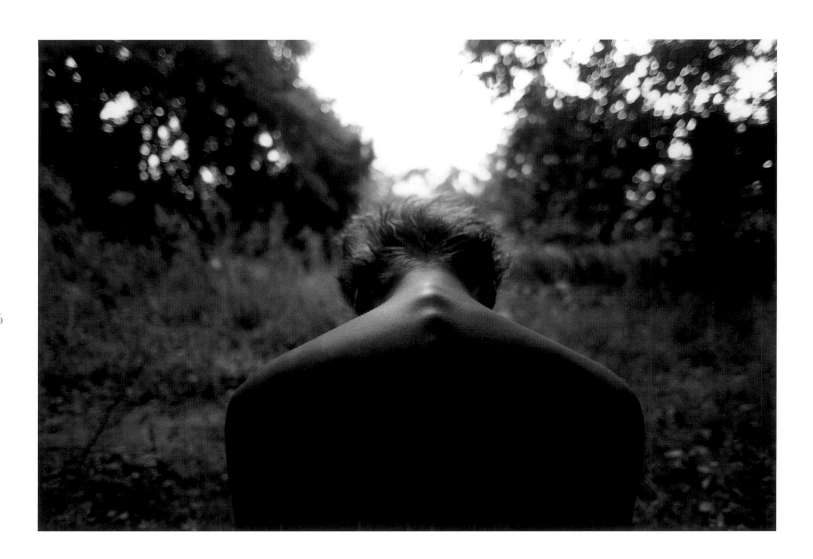

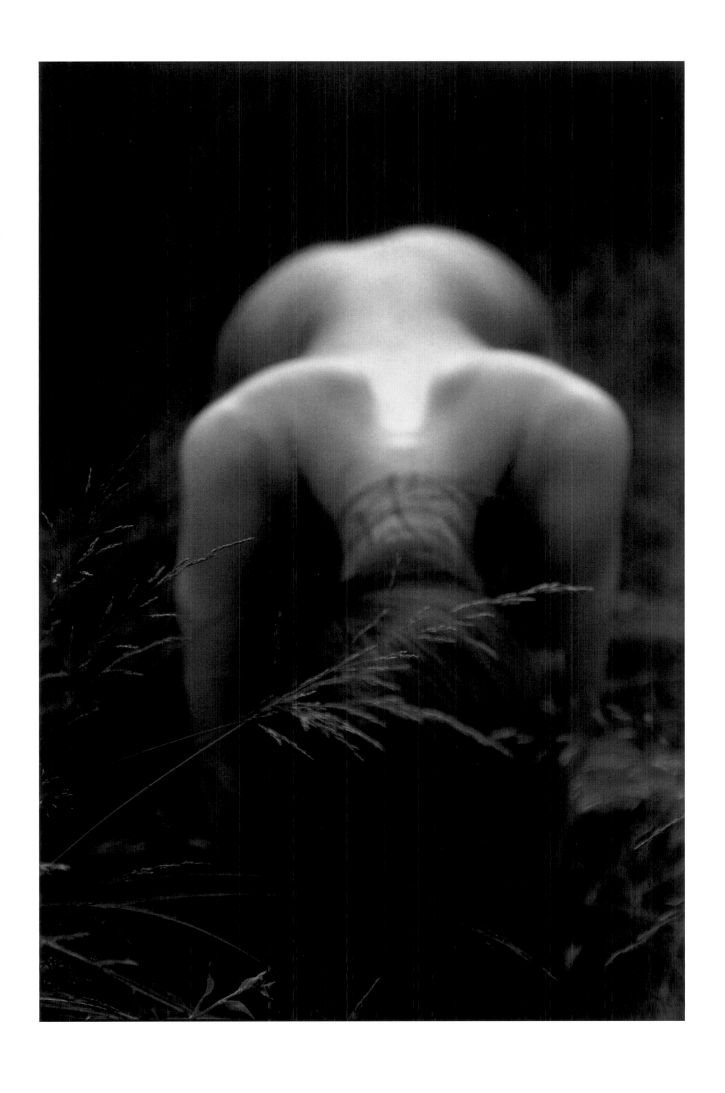

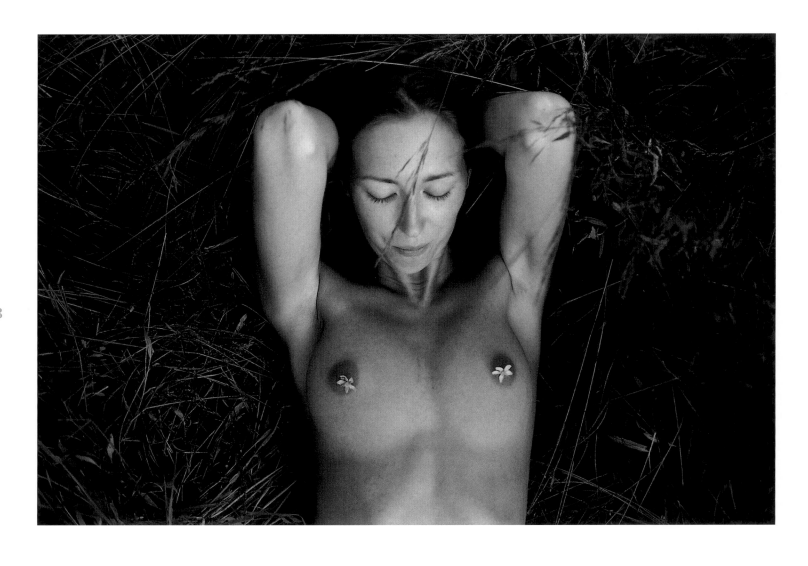

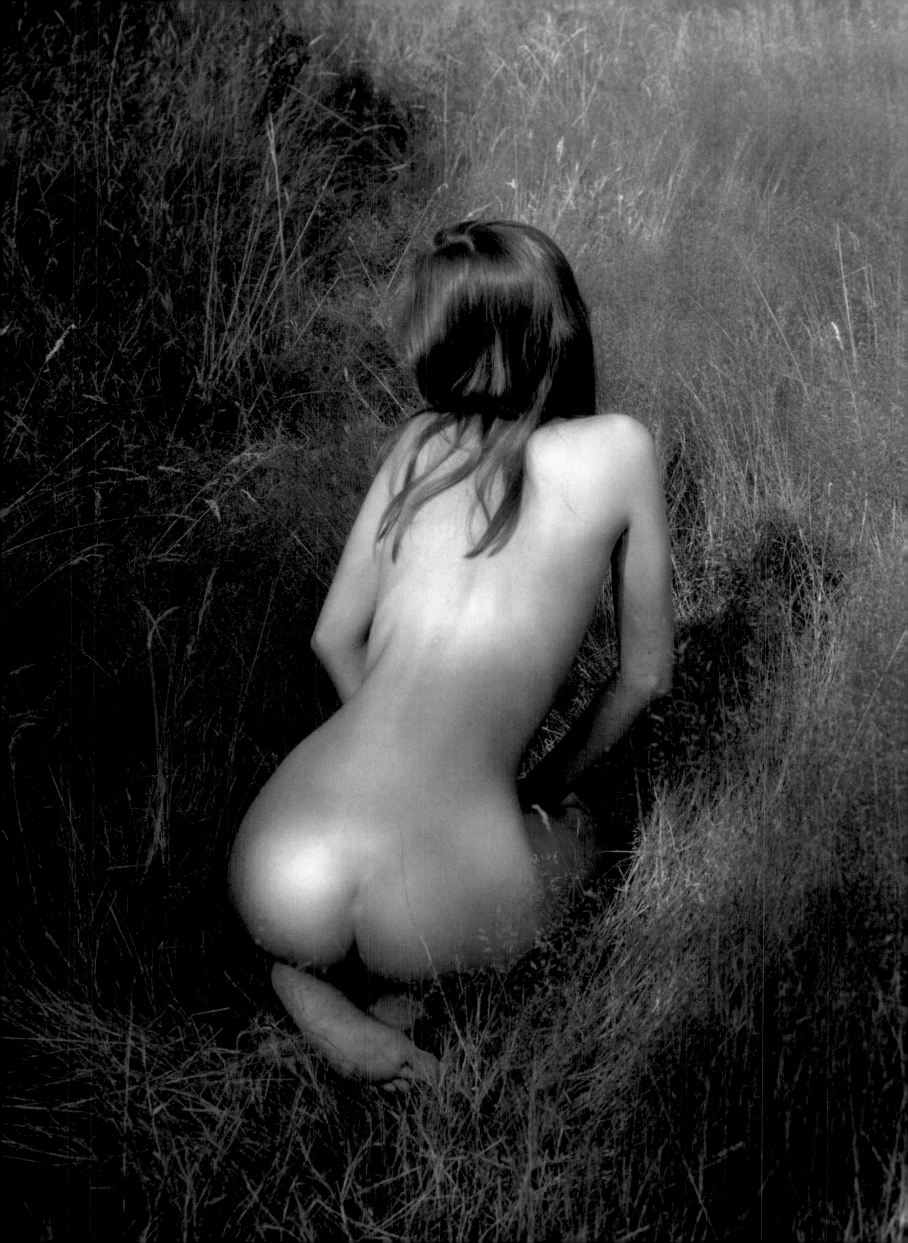

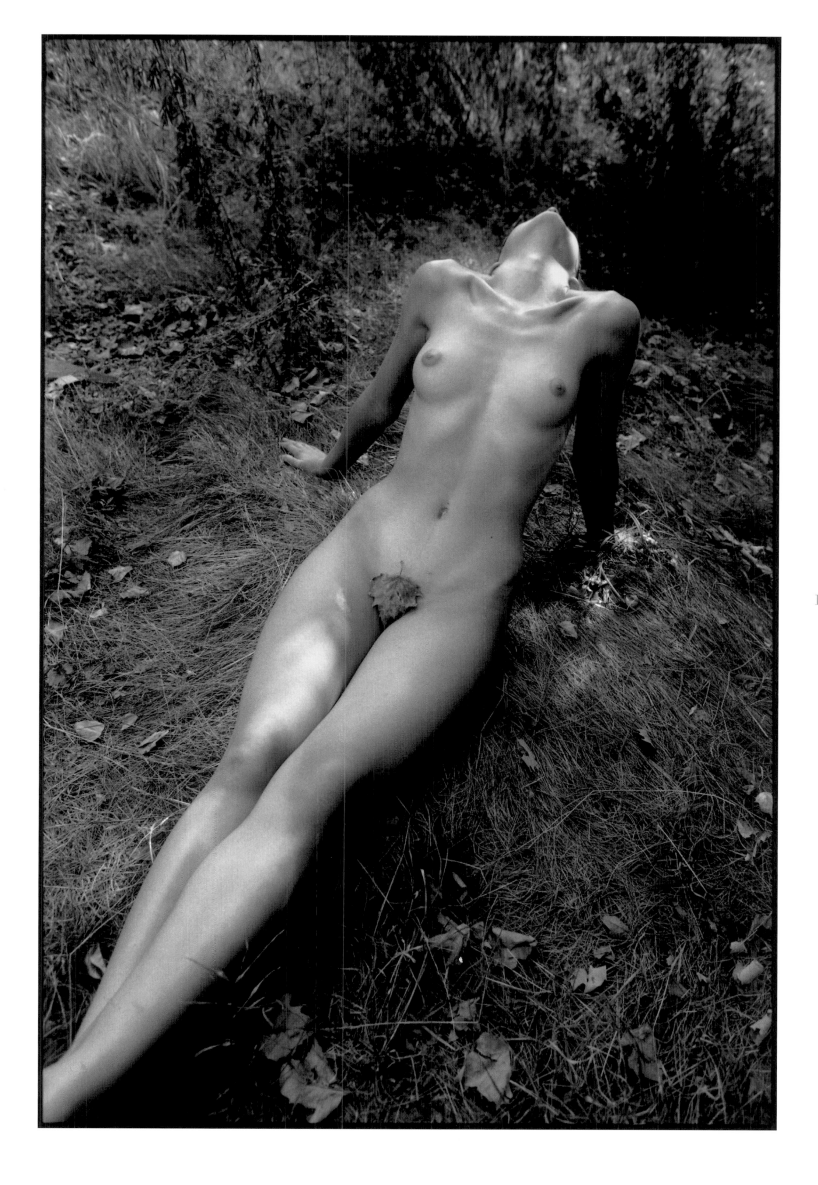

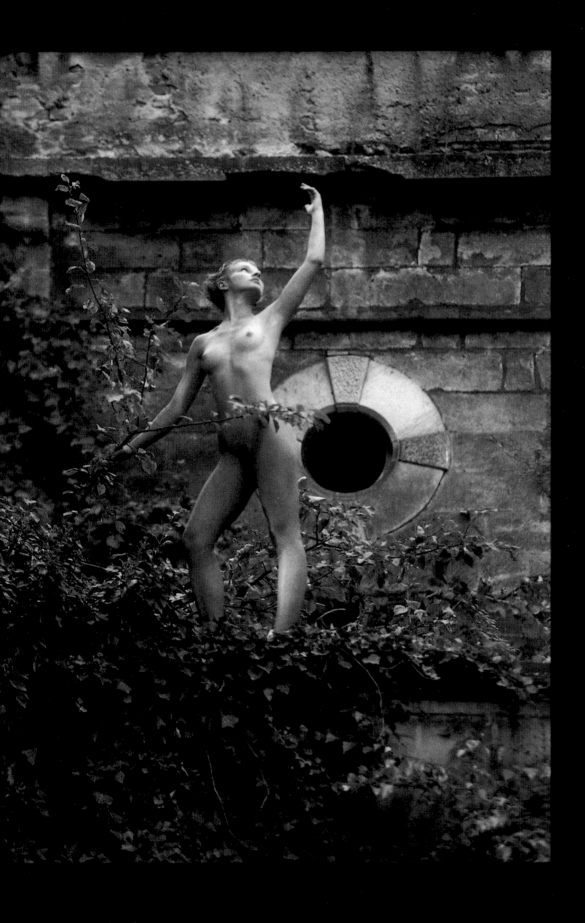

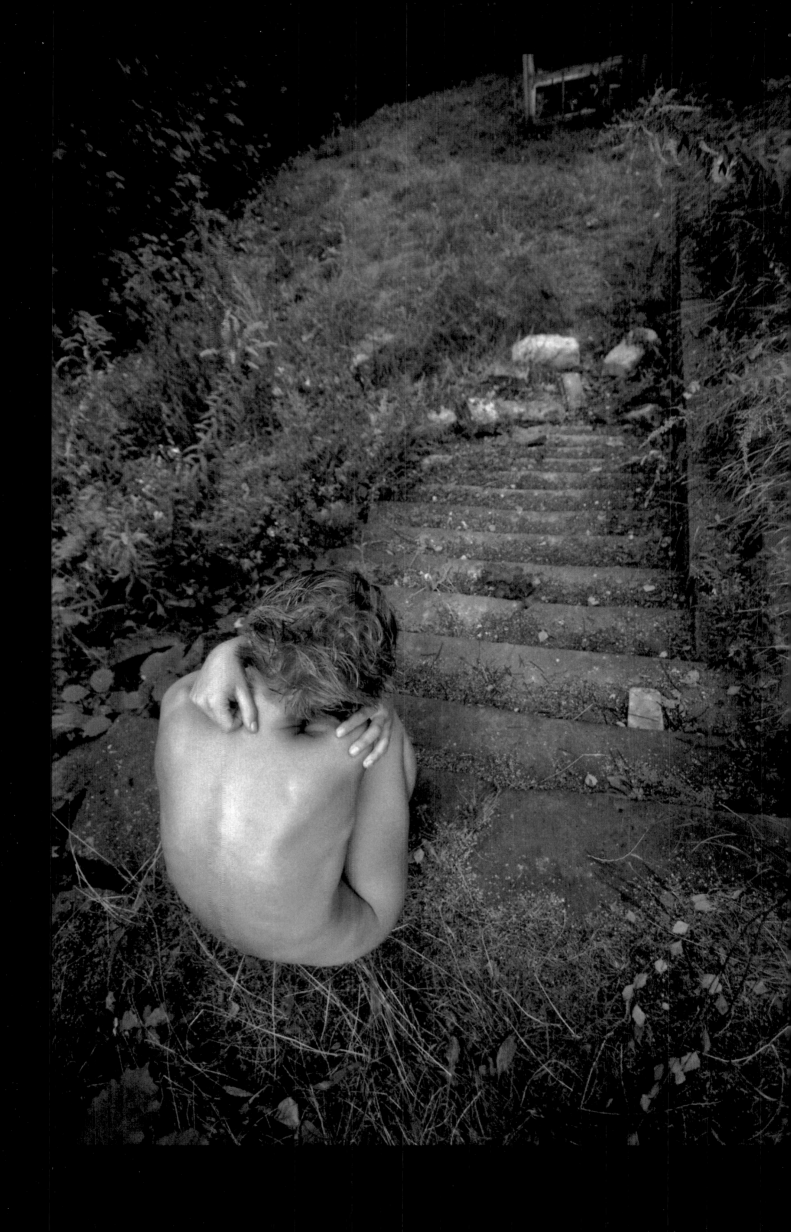

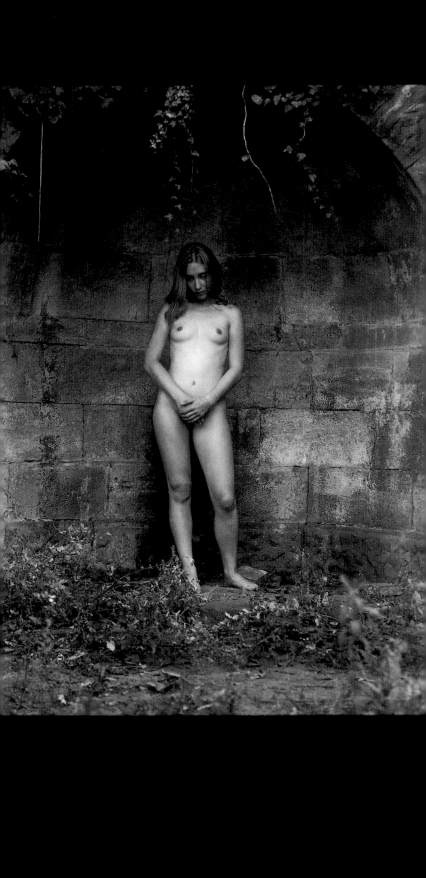

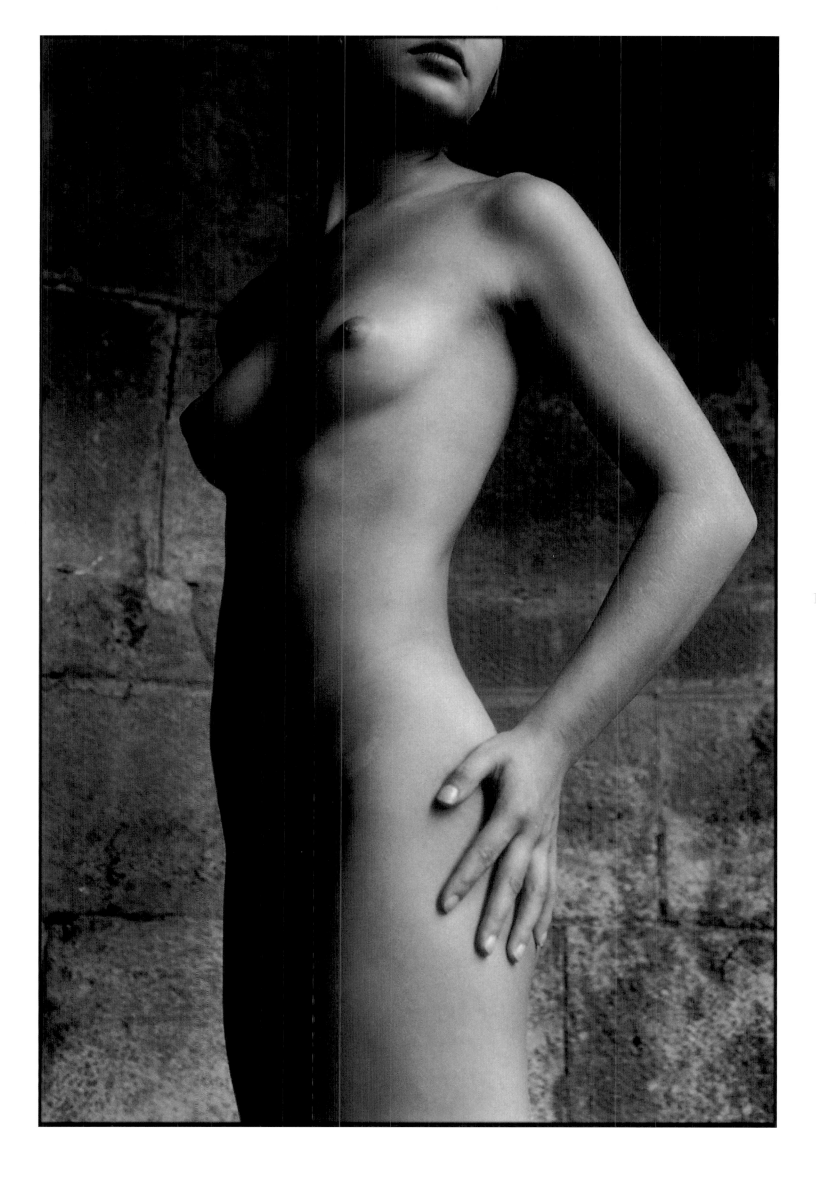

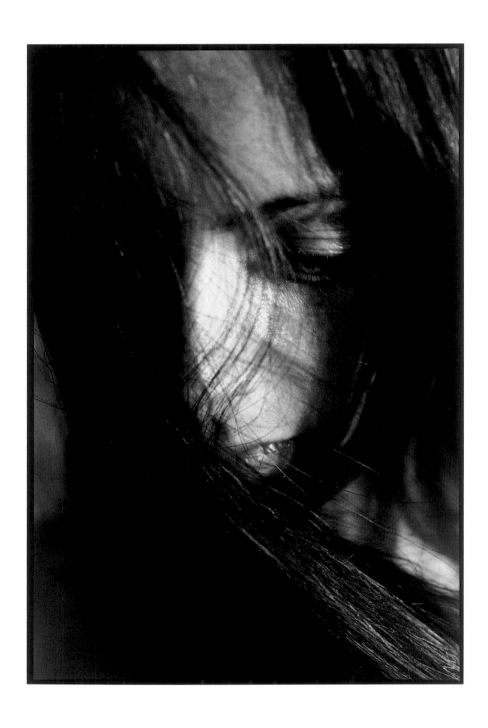

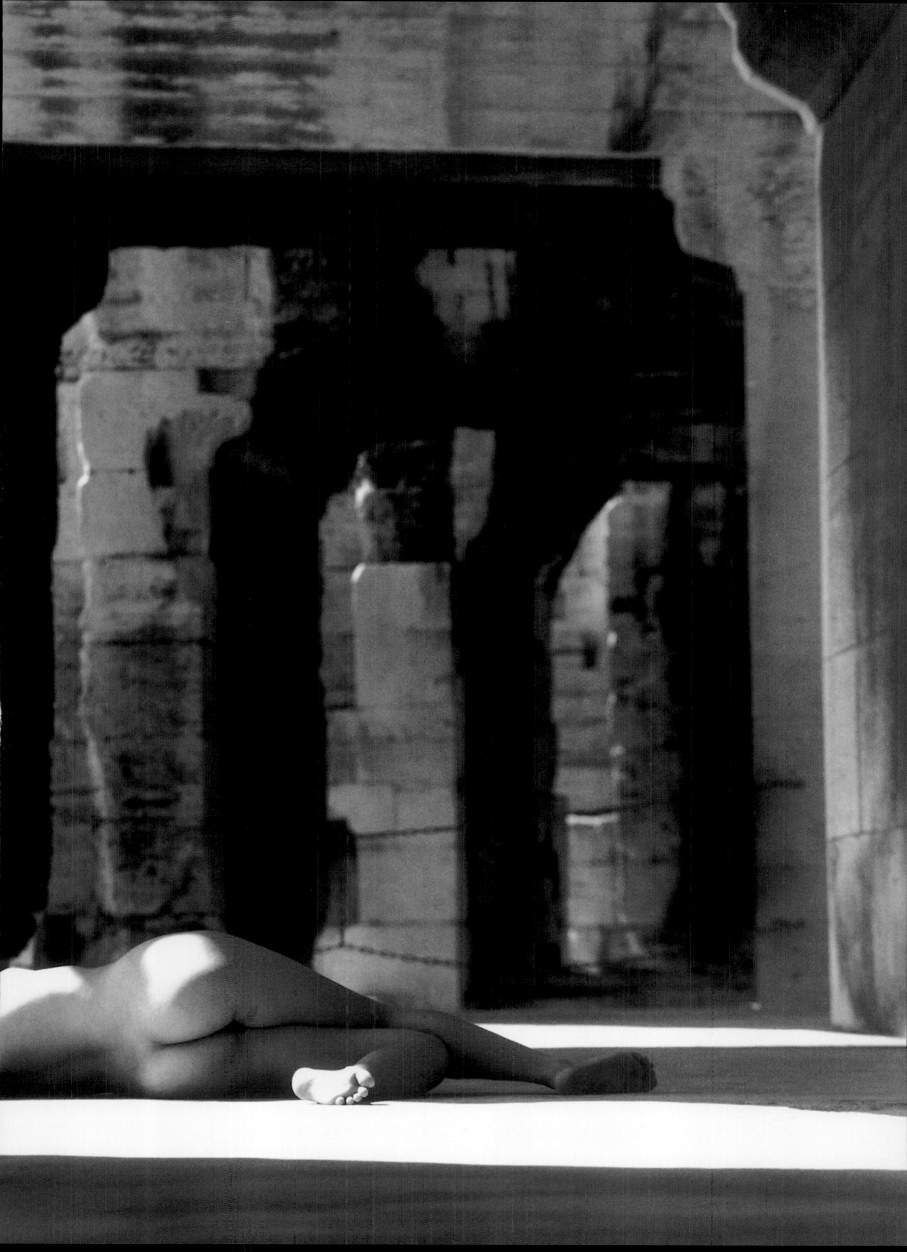

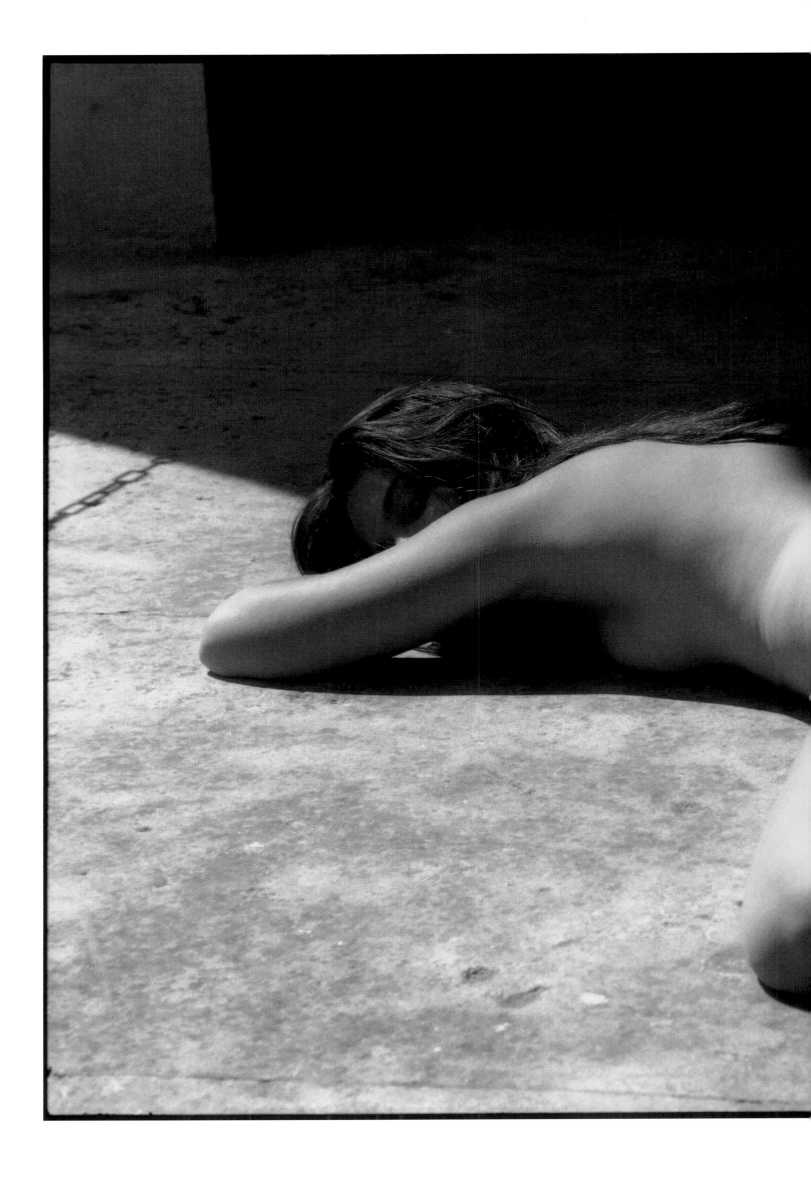

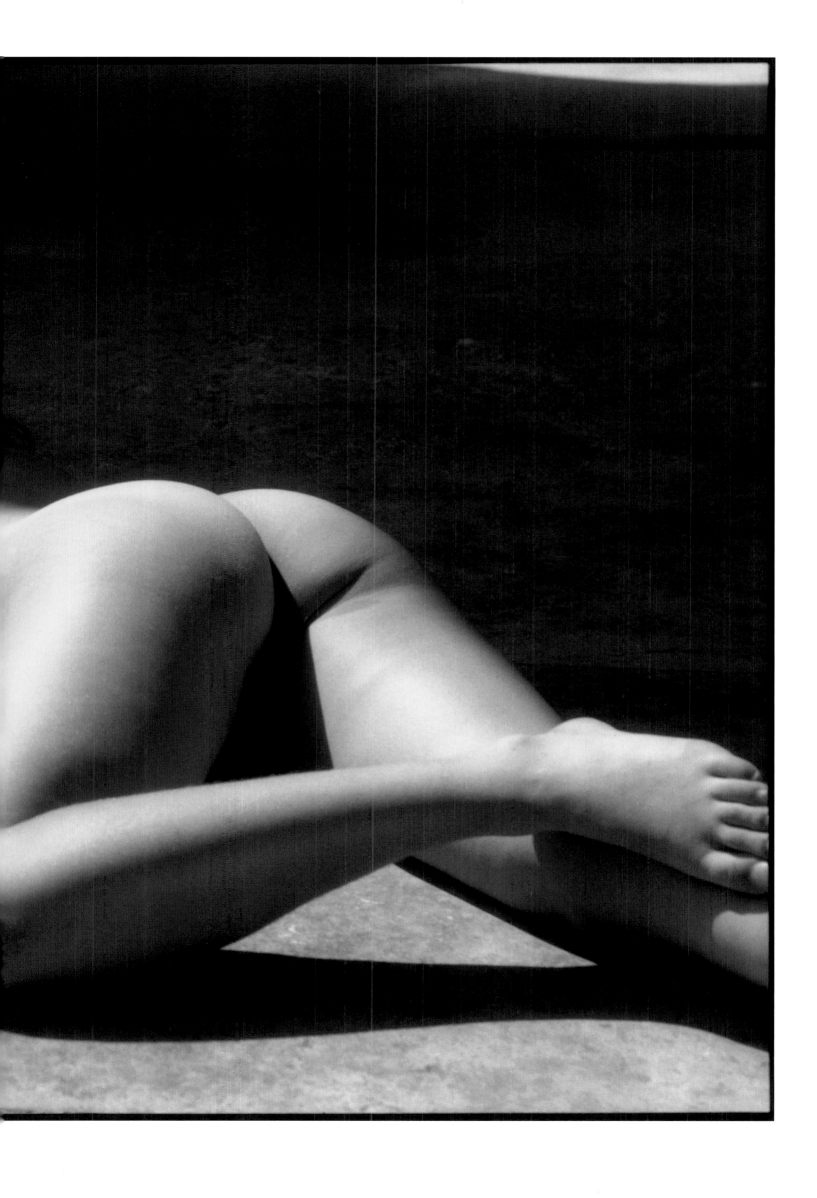

119

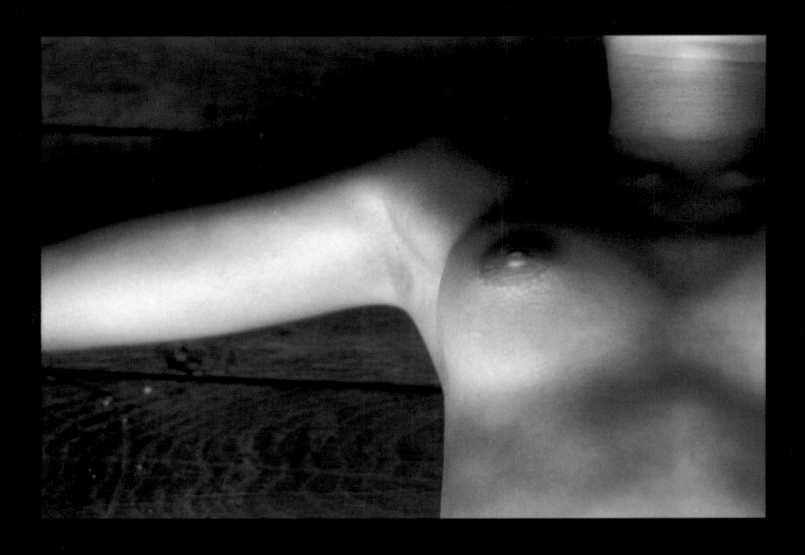

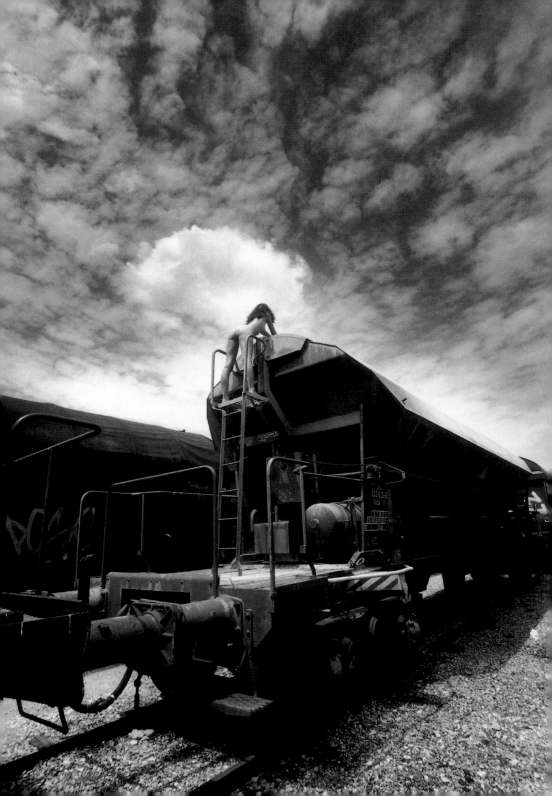

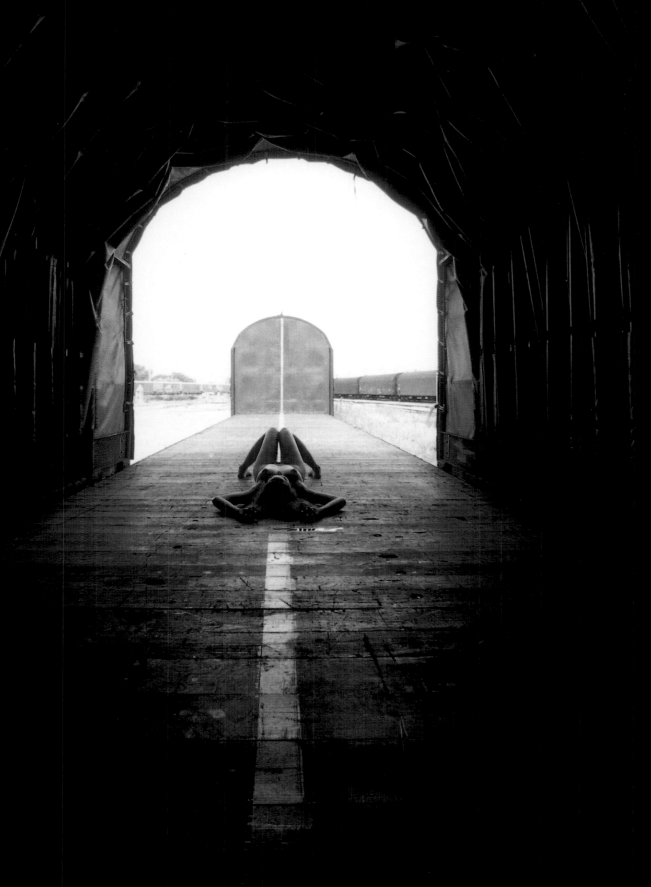

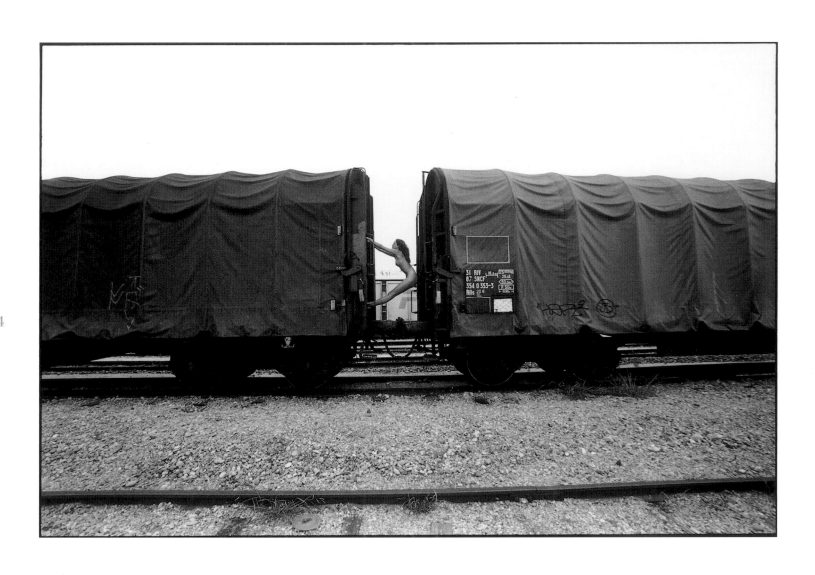

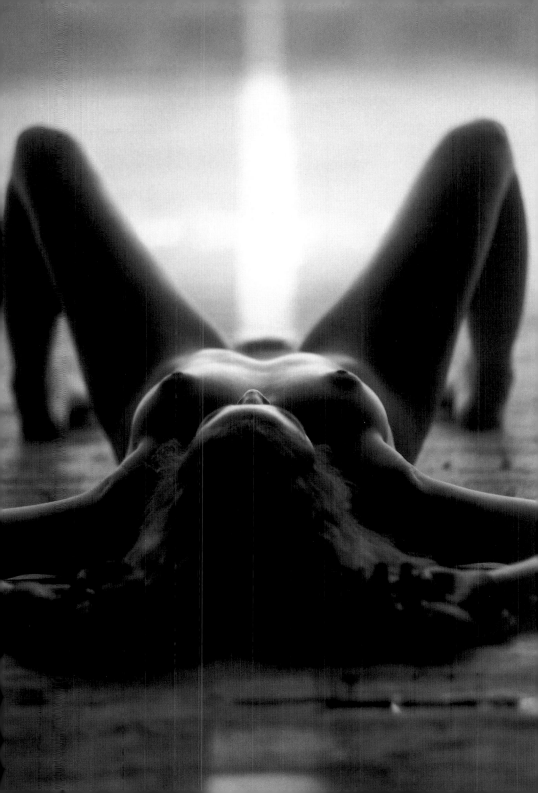

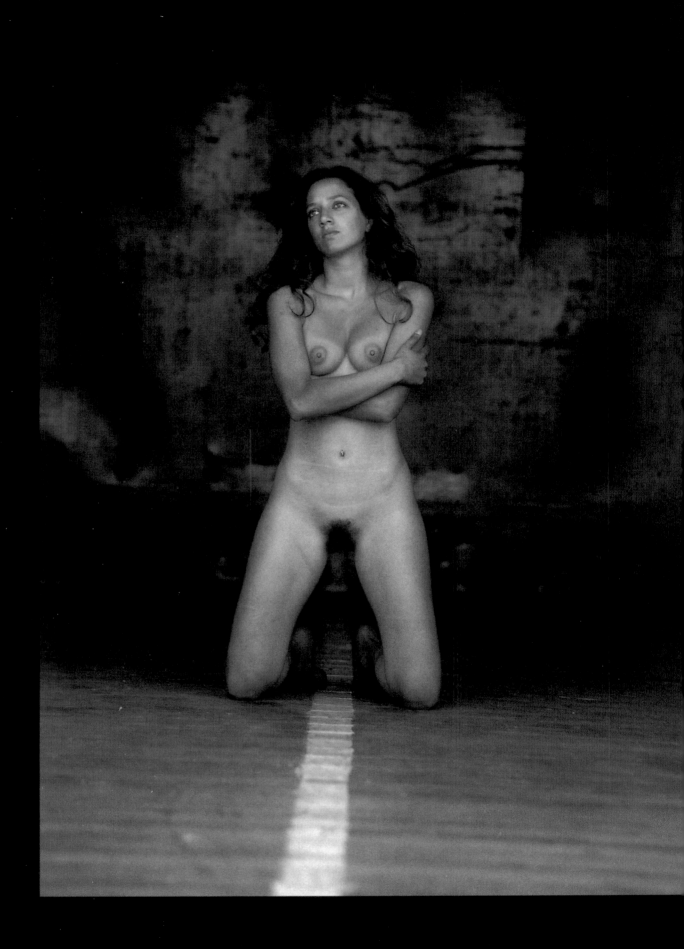

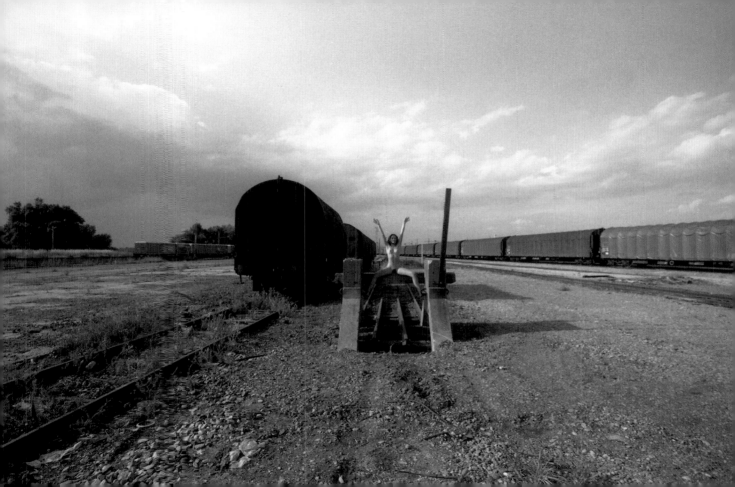

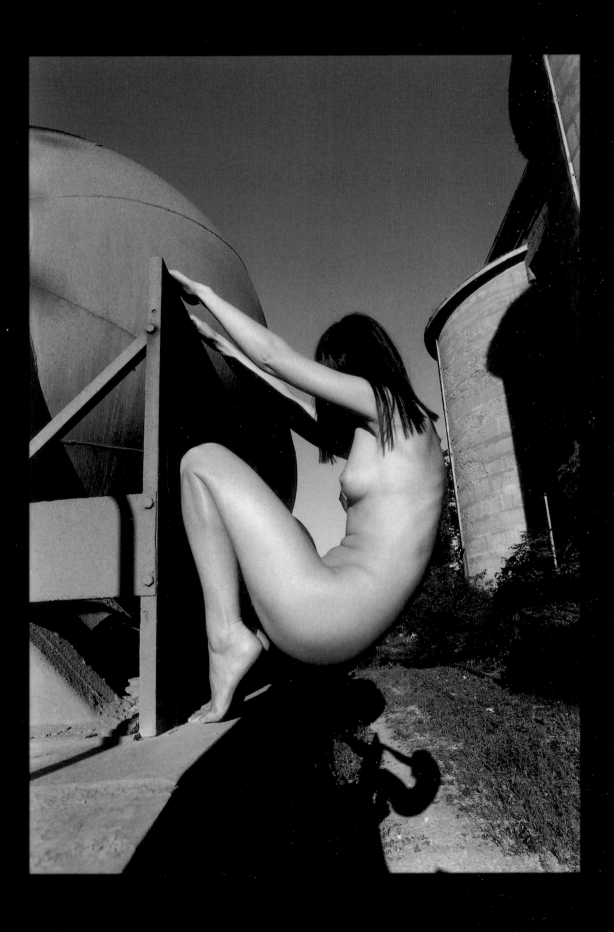

128

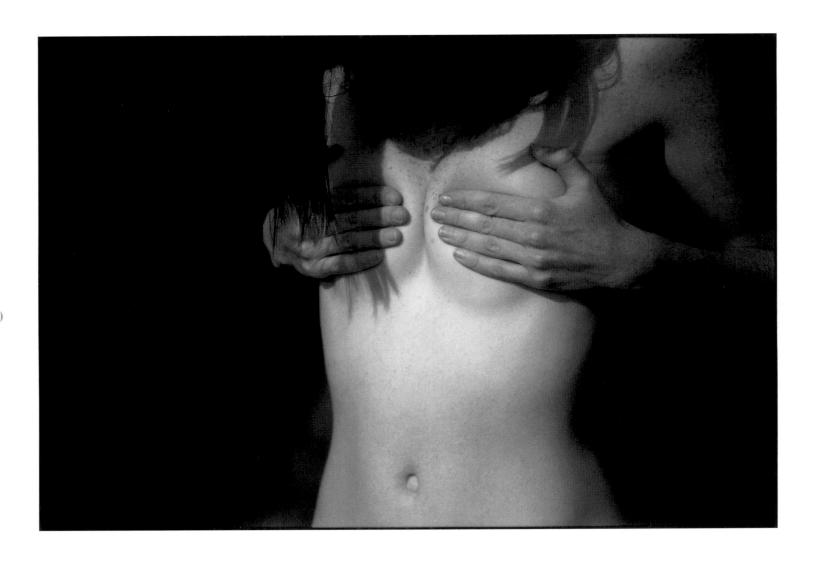

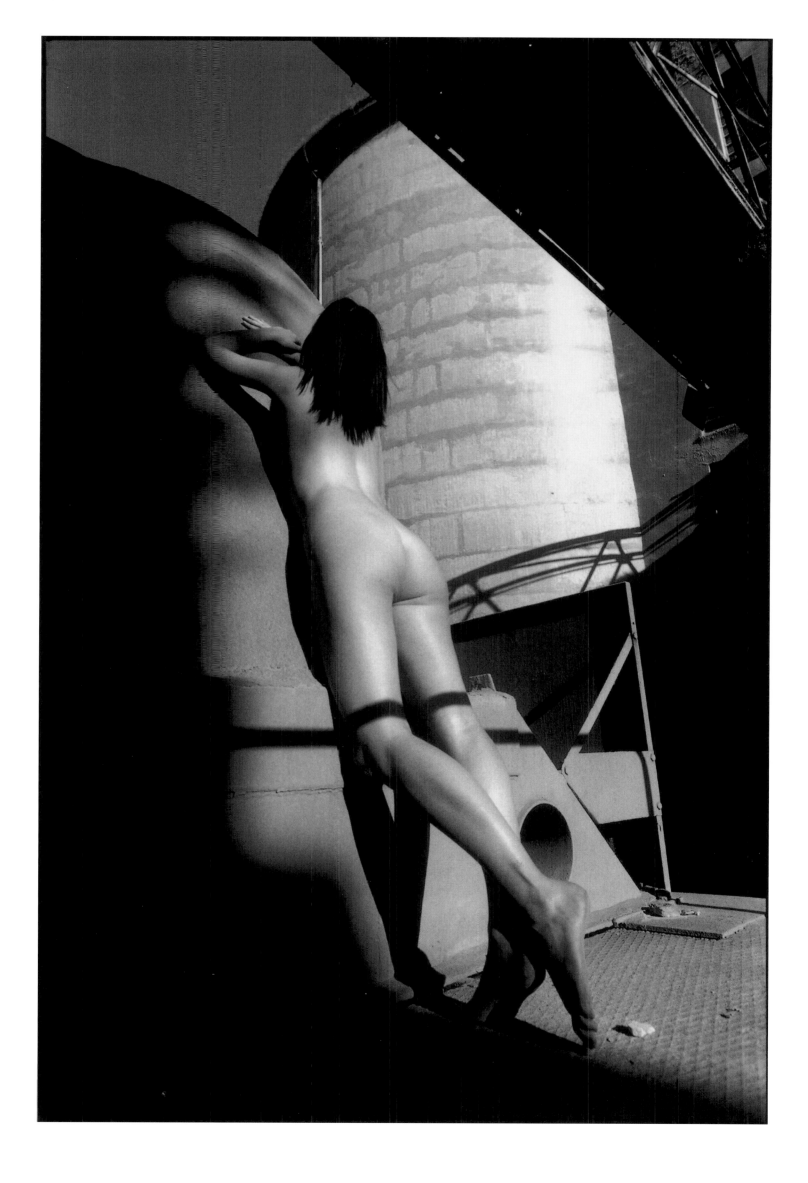

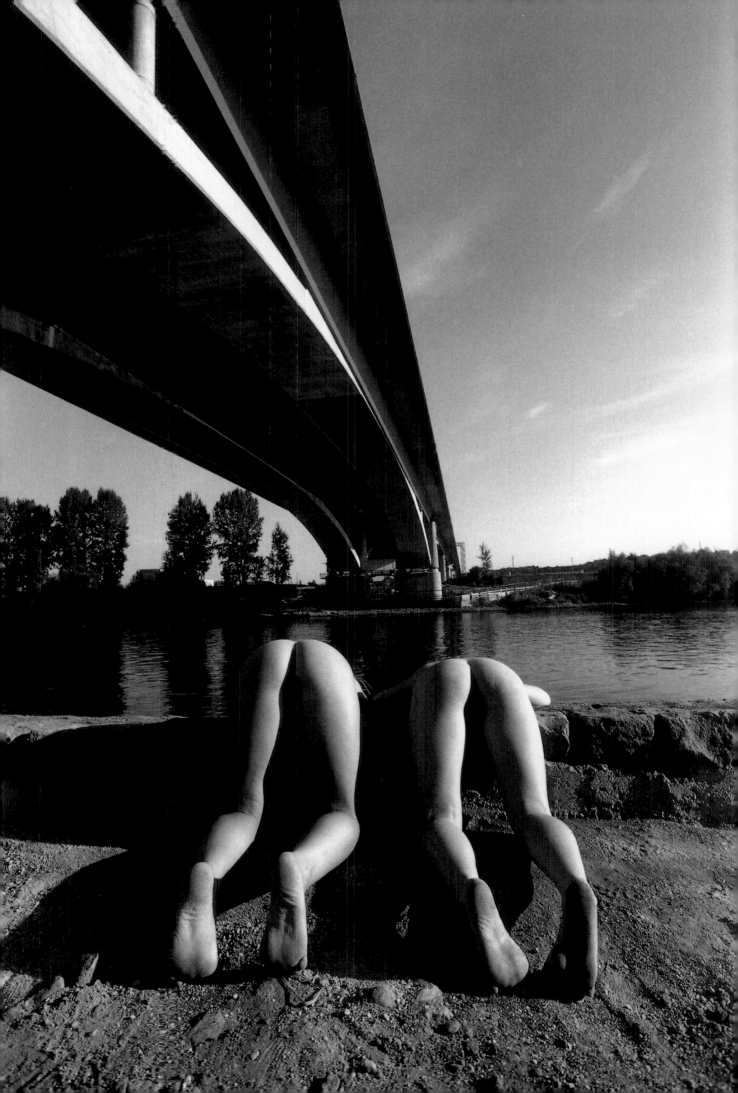

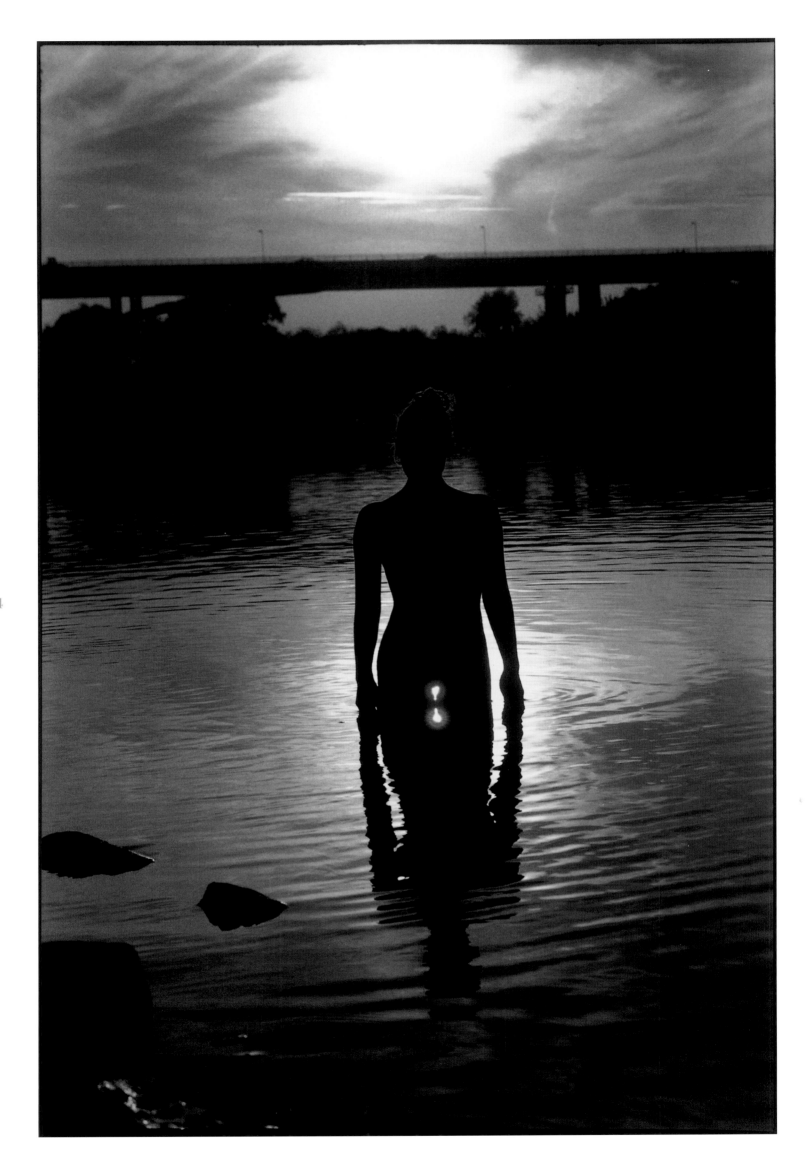

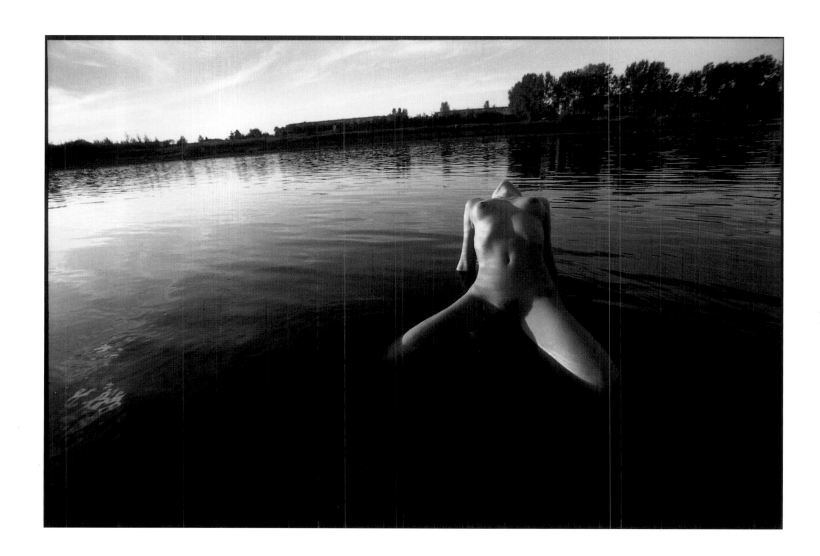

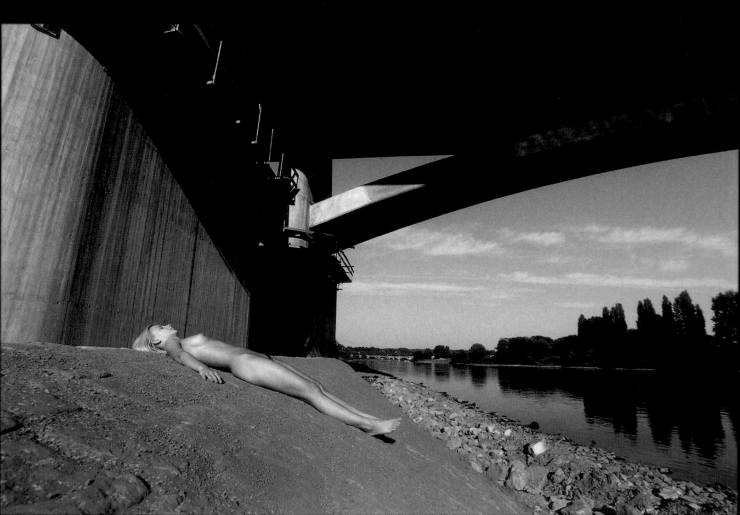

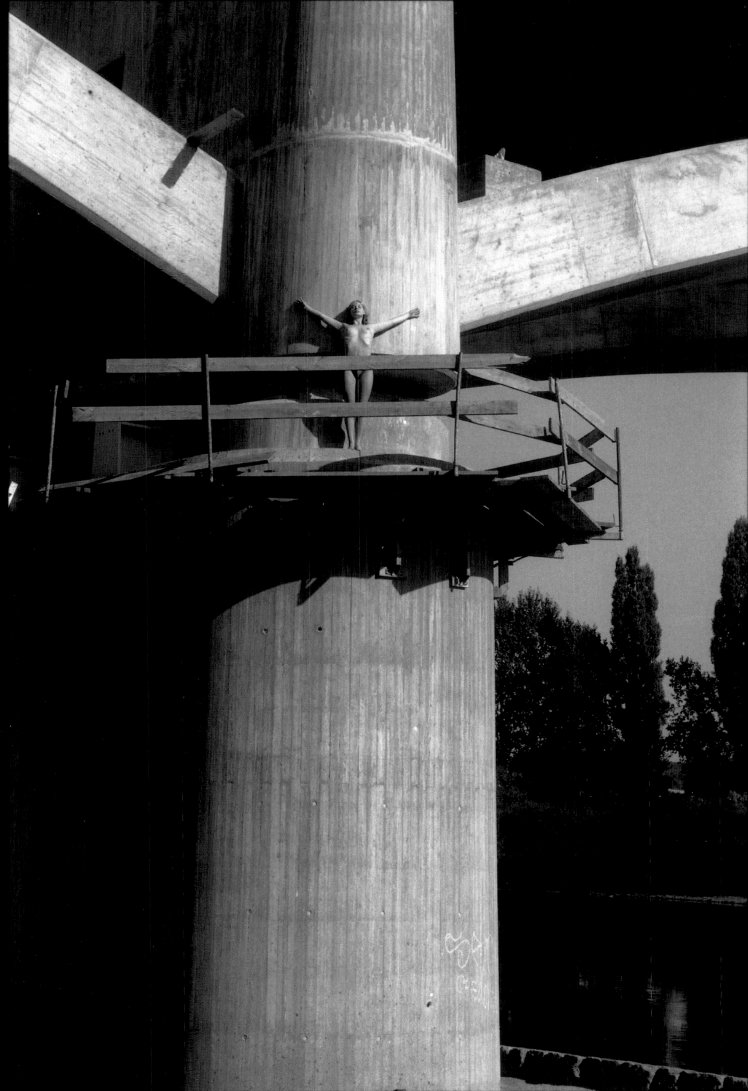

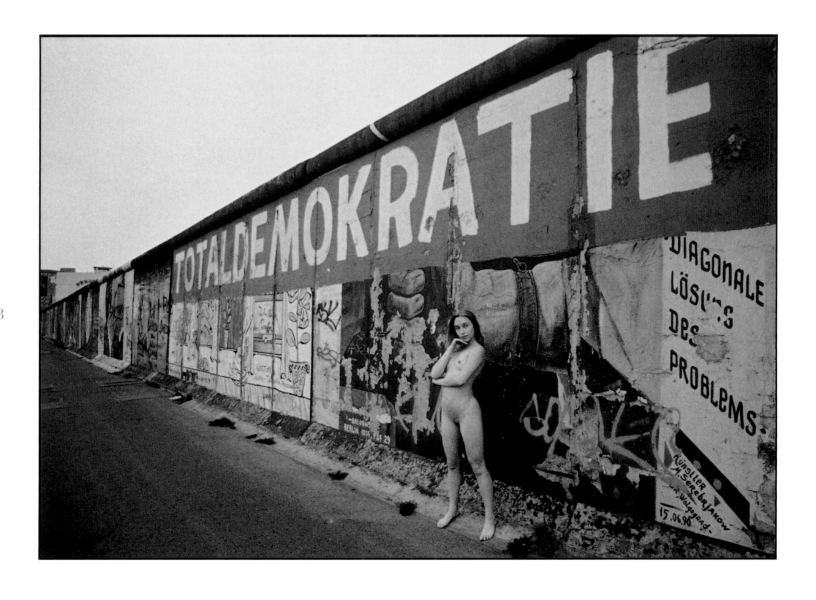

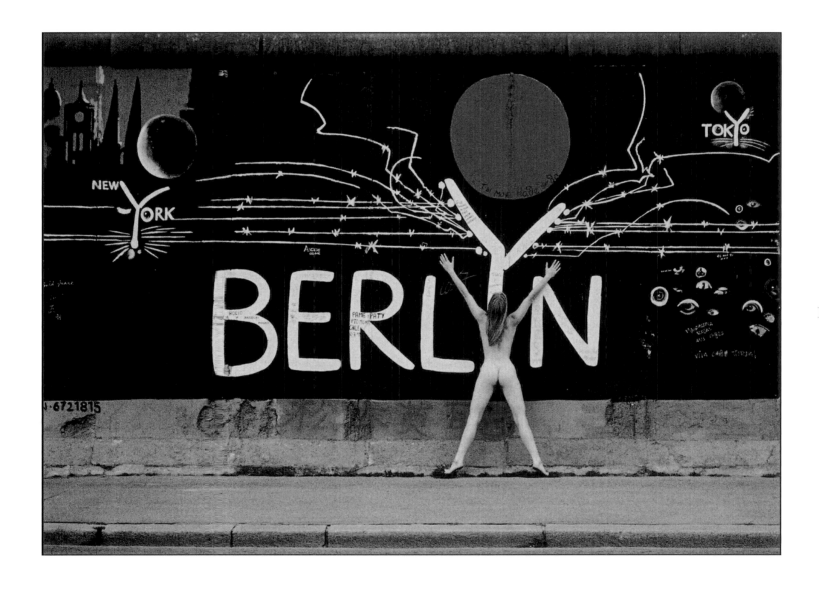

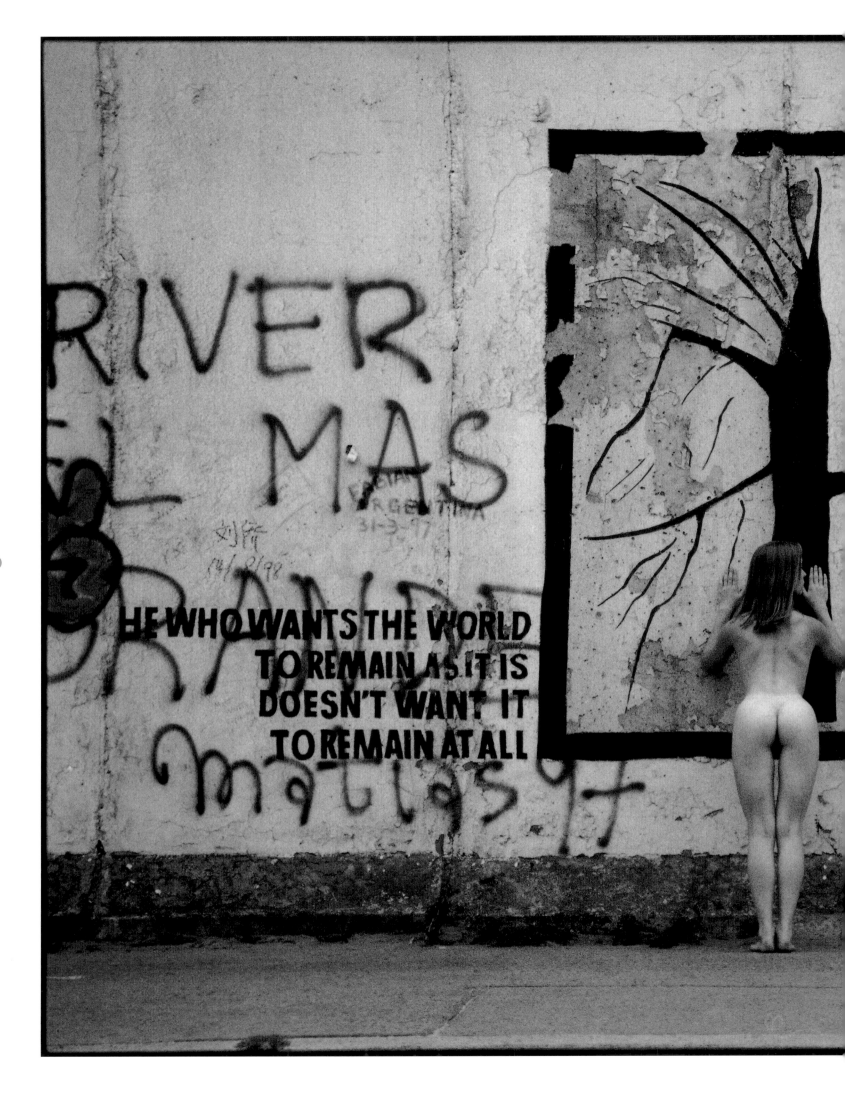

HE WHO WANTS THE WORLD
TO REMAIN AS IT IS
DOESN'T WANT IT
TO REMAIN AT ALL

WER WILL DASS
DIE WELT SO BLEIBT
WIE SIE IST
DER WILL
NICHT
DASS SIE
BLEIBT

CH FRIED

Acknowledgements

I would like to express my sincere thanks to the following people:
Amel, Ana, Ana-Maria, Anneleen, Aurély, Barbara, Bie, Carina, Charlotte, Claudia, Els, Evy, Jasmien, Jill, Julie, Karolien, Kathi, Kris, Kristien, Laetitia, Laurence, Lien, Marjolijn, Martina, Maud, Myra, Naomi, Nele, Sandra, Sofie, Susanne, Tine, Valentina, Virginie, Wendy, Zuri the beautiful young women who reveal an often hidden side of themselves in this photo collection; (and those who will have to wait for a next book to see their images published);
Jeff Dunas for the kind words of his introductory text; Carsten Muss-Prenzler and Hero Schiefer of Weingarten Kunstverlag for our pleasant cooperation;
Birgit De Leuze, Katja De Leuze, Mike Louagie, Bernd Mellmann, Nancy Verbeke, Bert Verlinden, Marnix Vermeulen, for their advice and support in the production of this book;
Rony Broun, George Dorogi, Nicolas Ducros, Tomislav Maric, Arthur Ongar, Pascal Polar, Andreas Schmidt, Tsjonca Siu and Danny Vermeeren and the other people who offered me the locations for taking my photographs and the facilities for displaying my work;
The late Fred J. Maroon, for his warm friendship, his wise words and his contagious addiction to photography and the sunny face of life;
Katja, Laura, Iris and Annie, my late father, my family and friends, for their presence and support. And that eternal muse deep inside.

Thank you!
Pascal Baetens.

Opposite page: "Maud, August 2000," in memory of Maud (1978–2000), who lost the battle with the murdered child inside her.

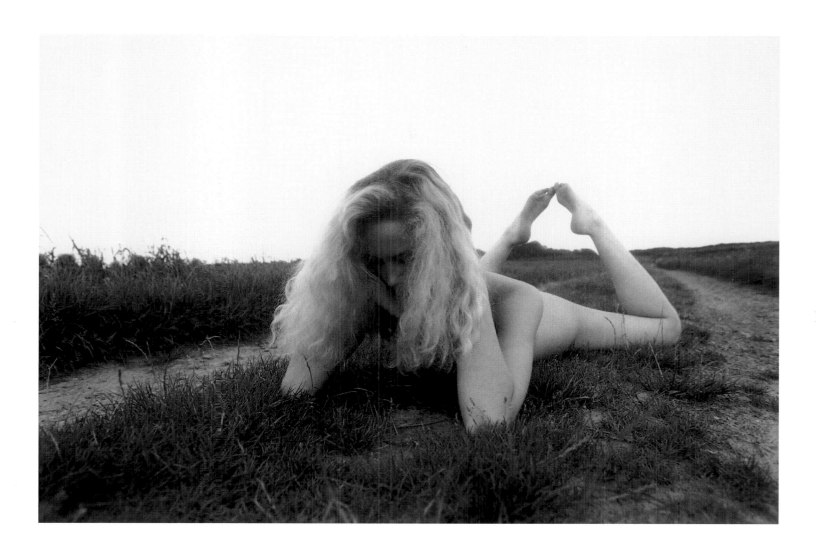

First published in 2003 in the United States by
Amphoto Books
an imprint of Watson-Guptill Publications
a division of VNU Business Media, Inc.
770 Broadway, New York, NY 10003
www.watsonguptill.com

First published in Germany in 2002 by Weingarten
Lägelerstraße 31, D-88250 Weingarten, Germany

Photographs by Pascal Baetens, Studio P.J.J.,www.pascalbaetens.com
Concept and photo selection: Pascal Baetens and Katja De Leuze, Studio P.J.J.
© Introduction: Jeff Dunas, www.dunas.com
Typesetting: Riedmayer GmbH, Weingarten
Reproductions: Repro-Team GmbH, Weingarten
Printing and Binding: Kösel GmbH & Co. KG, Kempten

Library of Congress Control Number: 2003105453

ISBN: 0-8174-3315-5

Printed in Germany

2 3 4 5 6 7 8/10 09 08 07 06 05